GREAT COMPOSERS
IN HISTORIC PHOTOGRAPHS

*244 Portraits from the
1860s to the 1960s*

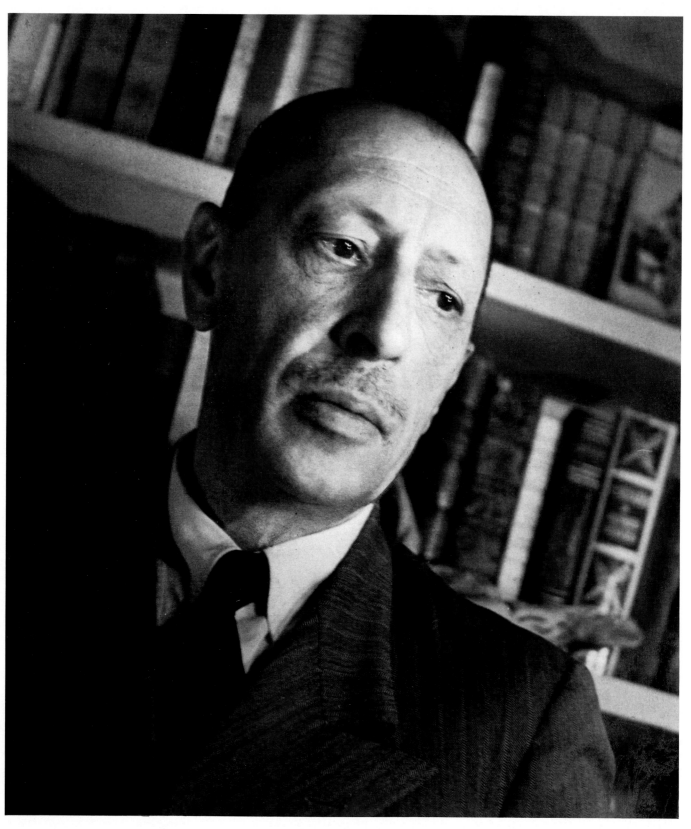

Igor Stravinsky (see No. 211).

GREAT COMPOSERS
IN HISTORIC PHOTOGRAPHS

244 Portraits from the
1860s to the 1960s

edited by
JAMES CAMNER

Dover Publications, Inc.
New York

Published in Canada by General Publishing Company, Ltd., 30 Lesmill Road, Don Mills, Toronto, Ontario.
Published in the United Kingdom by Constable and Company, Ltd., 10 Orange Street, London WC2H 7EG.

Great Composers in Historic Photographs is a new work, first published by Dover Publications, Inc., in 1981.

International Standard Book Number: 0-486-24132-7
Library of Congress Catalog Card Number: 80-70942

Manufactured in the United States of America
Dover Publications, Inc.
180 Varick Street
New York, N.Y. 10014

INTRODUCTION

The commercial success of photography, achieved by mid-nineteenth century, sent every celebrity into the eager arms of the studio photographer, who would churn out their images for the public. In the 1860s these took the form of cartes-de-visite; then came cabinet photos and finally postcard photographs, the last of the mass-manufactured photos.* The public avidly collected the photos of writers, actors, singers, political figures—and, of course, composers. The composers' photos were especially sought after and most faithfully preserved, and are consequently still abundant today. In this book, which is the largest collection of composers' photos to be published, almost all of the highly important composers who were photographed are represented, along with a broad spectrum of other interesting men and women composers.

If photography came too late to capture Bach, Handel or Mozart, we can at least be grateful that it could capture the composer at the height of his glory. For the age of photography coincided with the new status gained by composers. No longer were they regarded as bondsmen or as tradesmen only fit to come in by the servants' entrance. They had become almost deities.

Men like Johannes Brahms, Charles Gounod and Giuseppe Verdi were international celebrities more famous than kings. They were treated royally and received such treatment as their due. This regal status for composers peaked in the late nineteenth century, the time of the cabinet photos by Nadar, Reutlinger, Sarony, Dupont and the other great studio masters whose photographs show just how aware the composers were of their lofty position. Just look at Brahms, Gounod or Tchaikovsky, whose faces

*Before the invention of the carte-de-visite and other technical refinements, photographs printed on paper could not be reproduced in sufficient numbers to satisfy "fans" of celebrities; and, of course, the original daguerreotype had been a unique image on metal. The present volume does not attempt to cover this earlier period, but a reproduction of the famous daguerreotype of Fryderyk (Frédéric) Chopin, the great Polish pianist and composer (1810–1849), is included here as a record of a great early confrontation between composer and photographer.

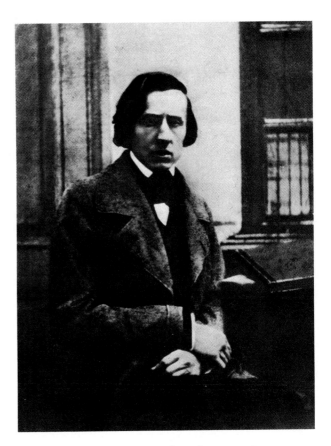

show the look of giants working for posterity, a grave responsibility.

Among all of the imperious photos are some surprises. One of the most startling is the one of Liszt in old age. The former glory of his looks has been ravaged by age. No painter or printmaker would have dared to be so candid. The wonder is that Liszt allowed such a photo to circulate without a great deal of retouching. Another odd photo is the one showing Ernest Bloch and his pupil Roger Sessions digging a ditch. Was this a form of relaxation from the terrors of modern music?

The book is full of rarities. Two of them are the youthful photo of Bruckner and the one of Mussorgsky, who is almost unobtainable in photographs. For all of these photos we are grateful to the many lenders, who are listed in the picture credits. We especially want to thank Lim Lai for his expert help, in addition to the many marvels from his collection.

PICTURE CREDITS

Editor and publisher are grateful to the following lenders of photographs:

Altman's Archives: 3, 7, 24, 43, 53, 62, 71, 87, 95, 104, 116, 125, 149, 166, 170, 190, 197, 218, 219, 227, 231.

Suzanne Bloch: 26, 27.

Arnold Broido (Theodore Presser Company): 2, 4, 5, 40, 42, 117, 120, 134, 138, 158, 179, 193, 212, 241.

Elliott Carter: 41.

James J. Fuld: 25.

Lim M. Lai: *frontispiece*, 1, 6, 9, 14, 15, 16, 17, 18, 19, 20, 21, 22, 23, 30, 33, 35, 37, 38, 44, 45, 46, 48, 51, 54, 56, 58, 60, 61, 64, 68, 69, 72, 76, 77, 79, 80, 82, 84, 88, 89, 92, 96, 98, 109, 112, 118, 119, 121, 124, 126, 127, 128, 129, 130, 132, 133, 137, 139, 140, 145, 146, 159, 162, 165, 168, 171, 172, 173, 174, 175, 176, 177, 178, 182, 183, 184, 188, 189, 192, 194, 195, 196, 198, 200, 201, 202, 203, 204, 207, 208, 209, 210, 213, 215, 216, 217, 220, 221, 223, 225, 226, 229, 230, 232, 234, 235, 238, 239, 240.

Dr. Margery Morgan Lowens: 131.

Moldenhauer Archives, Spokane, Washington: 243.

George Perle: 160.

(The late) William Schuman: 199.

Anna Sosenko: 81, 135, 148, 163, 214, 237.

Robert Tuggle: 52, 67, 85, 94, 99, 101, 102, 103, 115, 143, 147, 206, 224.

Hugo Weisgall: 242.

Dover Publications picture archives: 13.

Anonymous: 11, 34, 39, 49, 78, 83, 93, 106, 108, 122, 151, 152, 157, 161, 185.

All other photographs are from the collection of James Camner and the files of La Scala Autographs, Inc.

GREAT COMPOSERS
IN HISTORIC PHOTOGRAPHS

244 Portraits from the
1860s to the 1960s

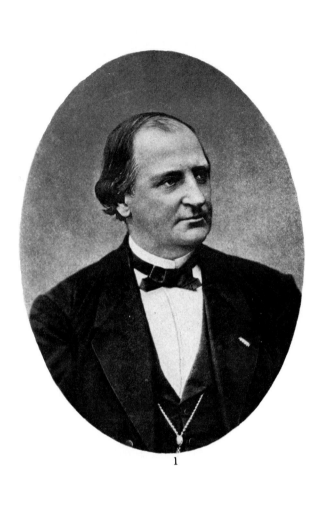

1

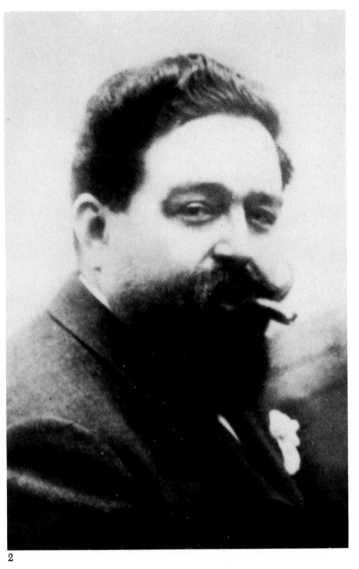

2

1. FRANZ ABT (1819–1885), German song composer and conductor. He wrote over 600 works and made a successful tour through America in 1872. (Photo: Paul Klemann, Hannover.) 2. ISAAC ALBÉNIZ (1860–1909), Spanish composer of operas and symphonic music. He is best known for his piano composition *Iberia*.

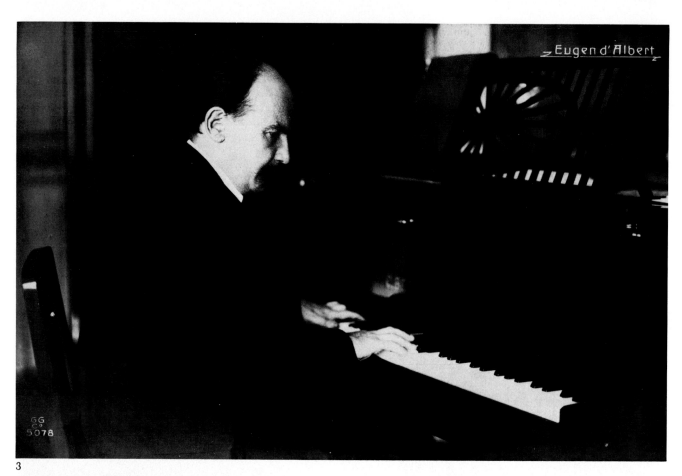

3

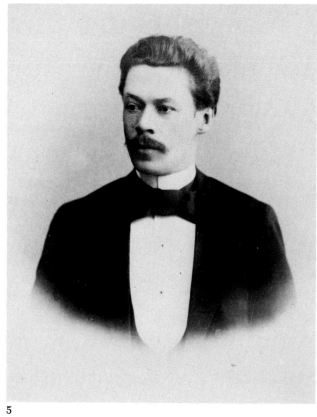

5

4

2

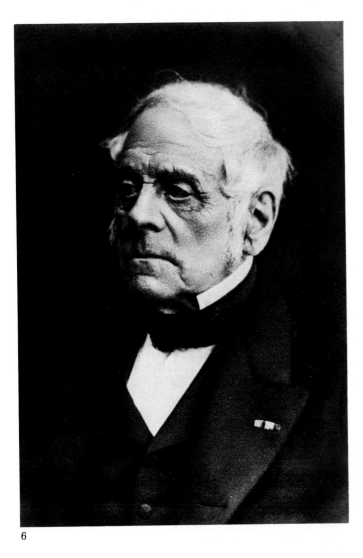

6

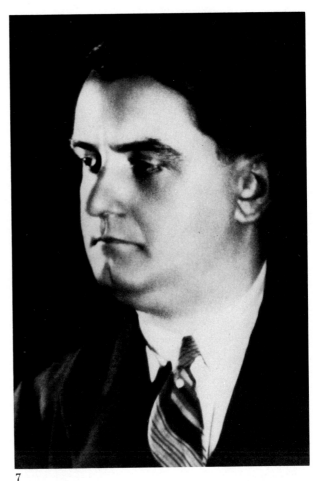

7

3. EUGÈNE D'ALBERT (1864–1932), German pianist and composer born in Britain. Studied composition with Stainer and Sullivan, piano with Liszt. Considered a foremost virtuoso, he was also a successful composer of 20 operas, of which *Tiefland* (1903) is the most famous. 4. GEORGE ANTHEIL (1900–1959), American composer and pianist. Student of Ernest Bloch. His many compositions included *Ballet Mécanique* (1926) as well as symphonies and film scores. He also made a successful tour of Europe as a concert pianist in 1920. 5. ANTON ARENSKY (1861–1906), Russian composer. He wrote operas patterned after those of Tchaikovsky and highly popular chamber works. (Photo: D. S. Zdobnova, St. Petersburg.) 6. DANIEL-FRANÇOIS-ESPRIT AUBER (1782–1871), French composer of comic and romantic operas. His most famous operas included *Fra Diavolo* (1830) and *Masaniello, ou la Muette de Portici* (1828), which caused revolutionary riots when performed in Brussels in 1830 thanks to its theme of revolt and freedom. His comic operas, such as *Le Cheval de bronze* (1835), *Le Domino noir* (1837) and *Manon Lescaut* (1856), helped establish the French style of operetta. 7. GEORGES AURIC (born 1899), French composer. Student of d'Indy and member of "Les Six." He worked with Diaghilev and composed the film music for *A Nous la Liberté* in 1931.

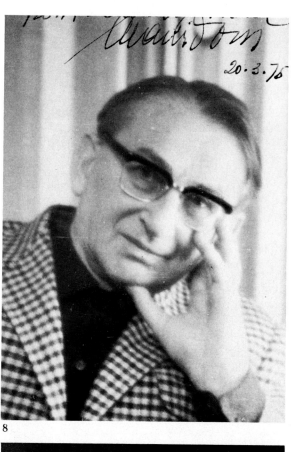

8

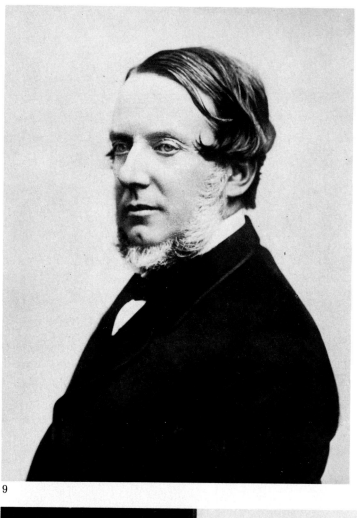

9

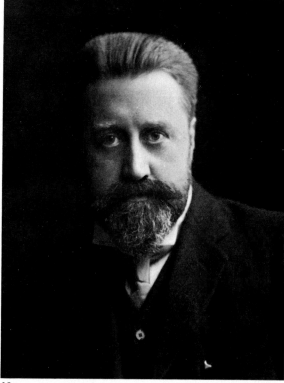

10

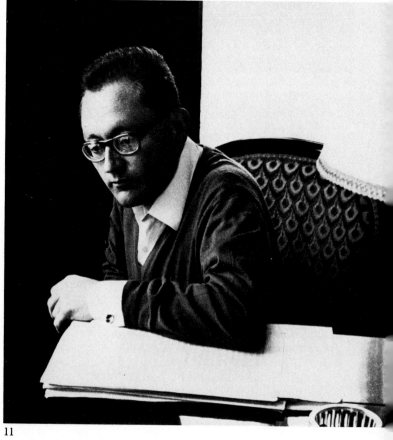

11

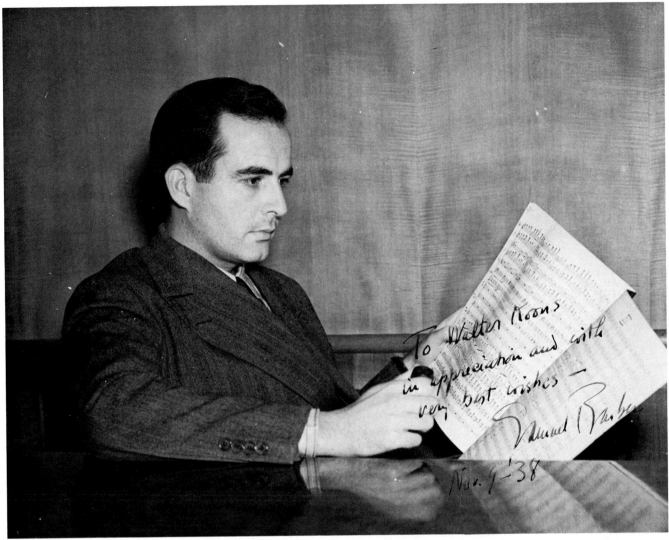

12

8. MENAHEM AVIDOM (born 1908), Israeli composer born in Poland. He has lived in Tel-Aviv since 1935 and has managed the Israel Philharmonic Orchestra. 9. MICHAEL WILLIAM BALFE (1808 –1870), Irish composer of operas and ballads. His best-known work is the English opera *The Bohemian Girl* (1843). 10. SIR GRANVILLE BANTOCK (1868–1946), British composer of operas, symphonies, chamber music and songs whose work is largely neglected today. 11. JEAN BARRAQUÉ (born 1928), French composer. Pupil and disciple of Messiaen. 12. SAMUEL BARBER (1910–1981), American composer. Educated at the Curtis Institute in Philadelphia, Barber was one of the few contemporary composers of classical music to have a modicum of success with his operas, especially *Vanessa* (1958). His *Antony and Cleopatra*, which opened the new Metropolitan Opera House in 1966, was a colossal failure. (Photo signed 1938.)

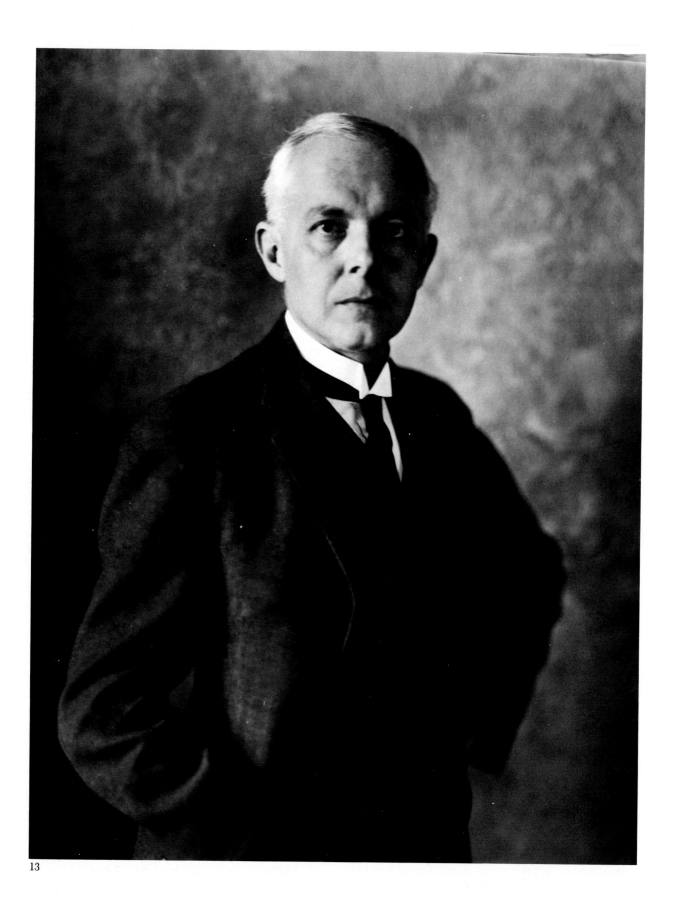

13

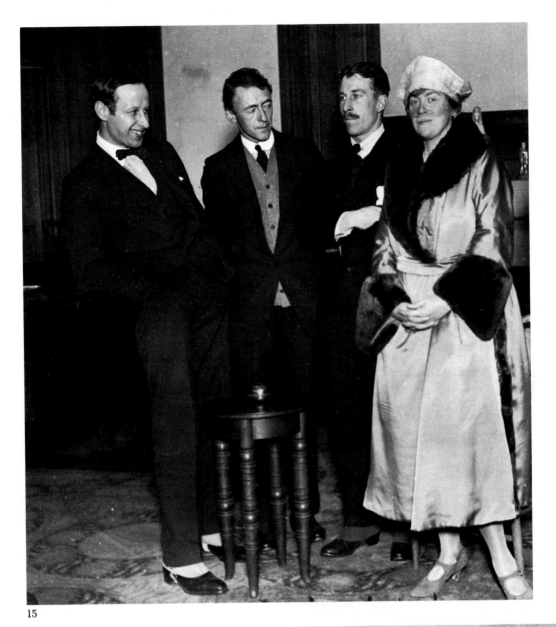

15

13 & 14. BÉLA BARTÓK (1881–1945), Hungarian composer, pianist and musicologist. One of the most celebrated composers of the century, he extensively employed folk motifs of southeastern Europe in his avant-garde music. In No. 14 he is seen with György Sándor (see No. 186). (Photo 13: Nickolas Muray, N.Y.) 15. SIR ARTHUR BLISS (born 1891), English composer of symphonic and film music (wearing light waistcoat). Beside him, with folded arms, is SIR EUGENE GOOSSENS (1893–1962), British conductor and composer of operas and oratorios. The other man is the poet Clifford Bax; the woman is the soprano Dorothy Moulton. (Photo: Underwood & Underwood, N.Y.)

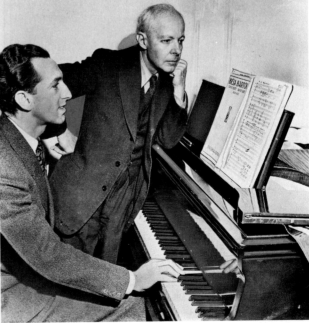

14

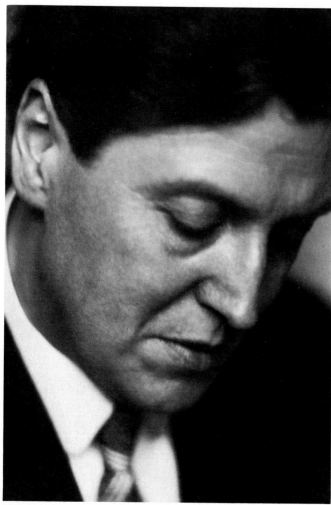

16

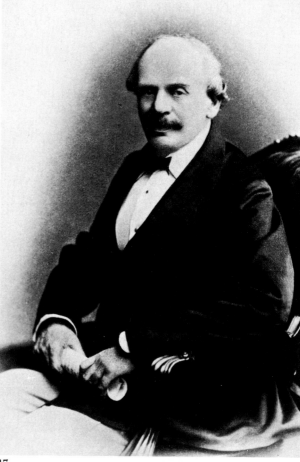

17

16. ALBAN BERG (1885–1935), Austrian composer. Student of Schoenberg, from whom he adopted his 12-tone technique and philosophy of atonal music. His operas *Wozzeck* (composed in 1925) and *Lulu* (left unfinished) are highly acclaimed. (Photo: Trude Fleischmann, Vienna.) 17. SIR JULIUS BENEDICT (1804–1855), British composer born in Germany. A pupil of Weber at the age of 17, he later composed many successful operas including *The Lily of Killarney*. (Photo: Window & Grove.)

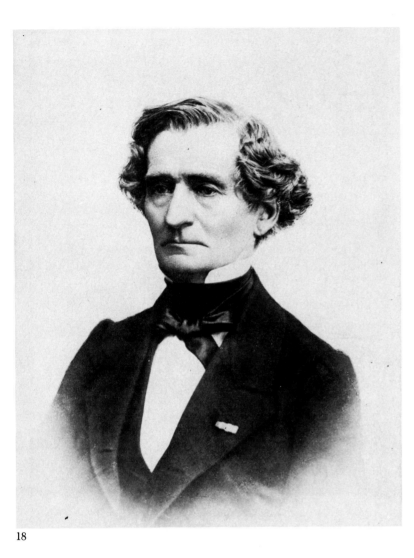

18

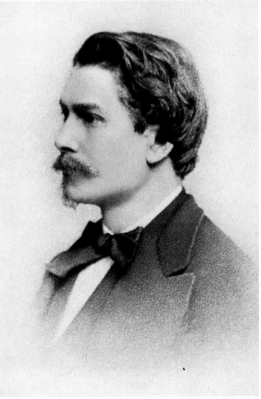

19

18. HECTOR BERLIOZ (1803–1869), French composer. His great originality impeded his popularity during his lifetime, but today he is regarded as a master composer for such works as *Harold in Italy*, *Symphonie Fantastique* and his operas, which include *Béatrice et Bénédict* and *Les Troyens*. 19. CHARLES-WILFRIDE DE BÉRIOT (1883–1914), French pianist and composer, pupil of Thalberg.

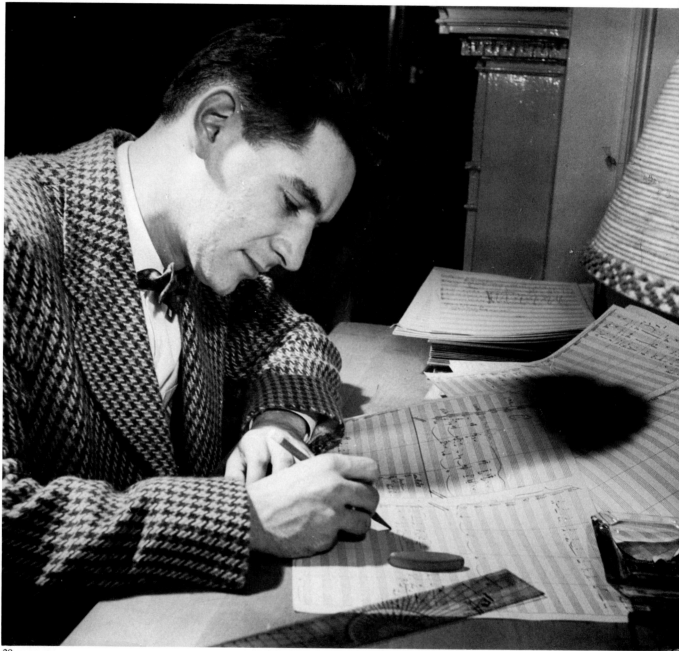

20

20. LEONARD BERNSTEIN (born 1918), American composer and conductor of enormous popularity. None of his many classical compositions, except perhaps for the ballet *Fancy Free*, has had anything near the success of his great musical *West Side Story*, composed in 1957. See also No. 192. (Photo: Erich Kastan, 1945.)

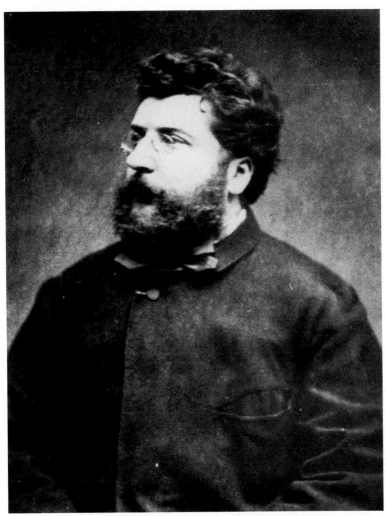

21

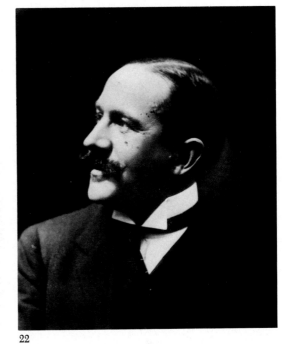

22

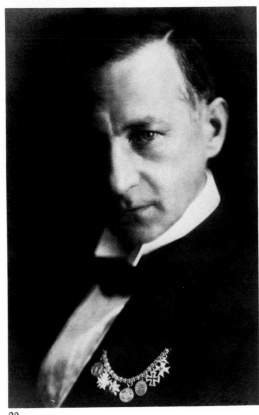

23

21. GEORGES BIZET (1838–1875), French composer whose *Carmen* has been called "the perfect opera." Other Bizet operas include *The Pearl Fishers* and *La jolie fille de Perth*. 22. EMILE R. BLANCHET (1877–1943), Swiss composer and pianist. He wrote the pedagogic *64 Preludes for Pianoforte in Contrapuntal Style*, among many works. (Photo: F. De Jongh.) 23. LEO BLECH (1871–1958), eminent German conductor who composed several operas, of which the most famous was *Das war ich* (1902). (Photo signed 1923.)

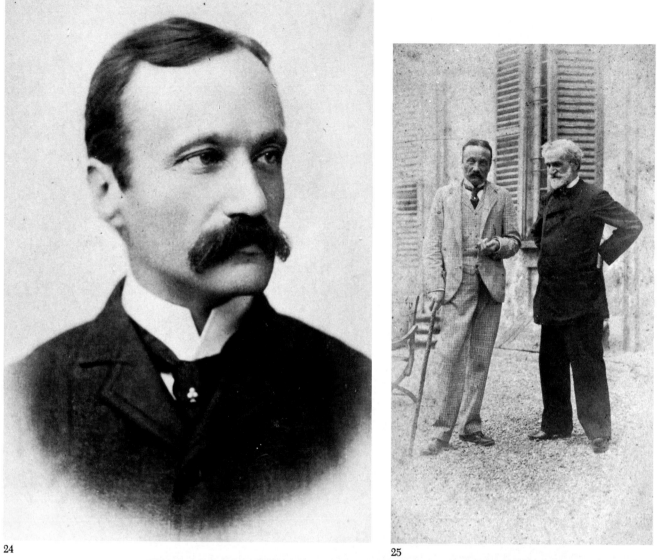

24

25

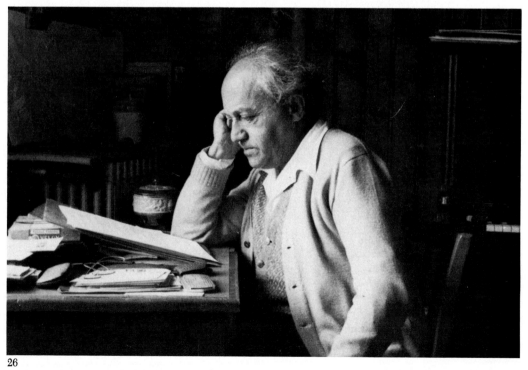

26

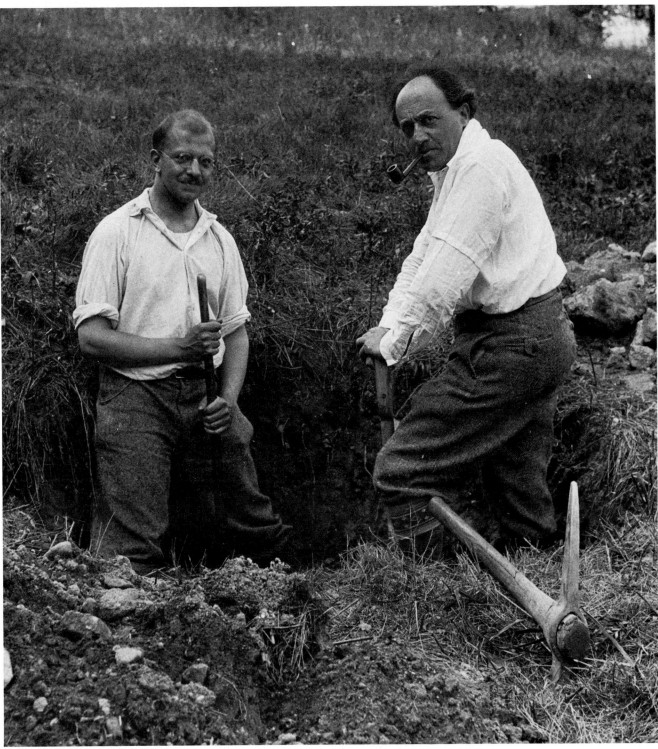

27

24. ARRIGO BOITO (1842–1918), Italian opera composer and librettist. His opera *Mefistofele* (1868), a work of great originality, is still in the repertory but his possibly greater *Nerone*, finished by Toscanini (Boito had worked on it for almost 50 years), remains largely unknown except for a private recording. Boito is best remembered for his libretti for Verdi's masterpieces *Otello* and *Falstaff*. 25. BOITO with Verdi (see also No. 230). 26. ERNEST BLOCH (1880–1959), Swiss-American composer. Bloch wrote a notable opera, *Macbeth* (1910), and several works based on Jewish culture, including *Schelomo* (for cello and orchestra, 1916). (Photo taken by Bloch.) 27. Bloch with his eminent pupil Roger Sessions (see No. 192) in 1923.

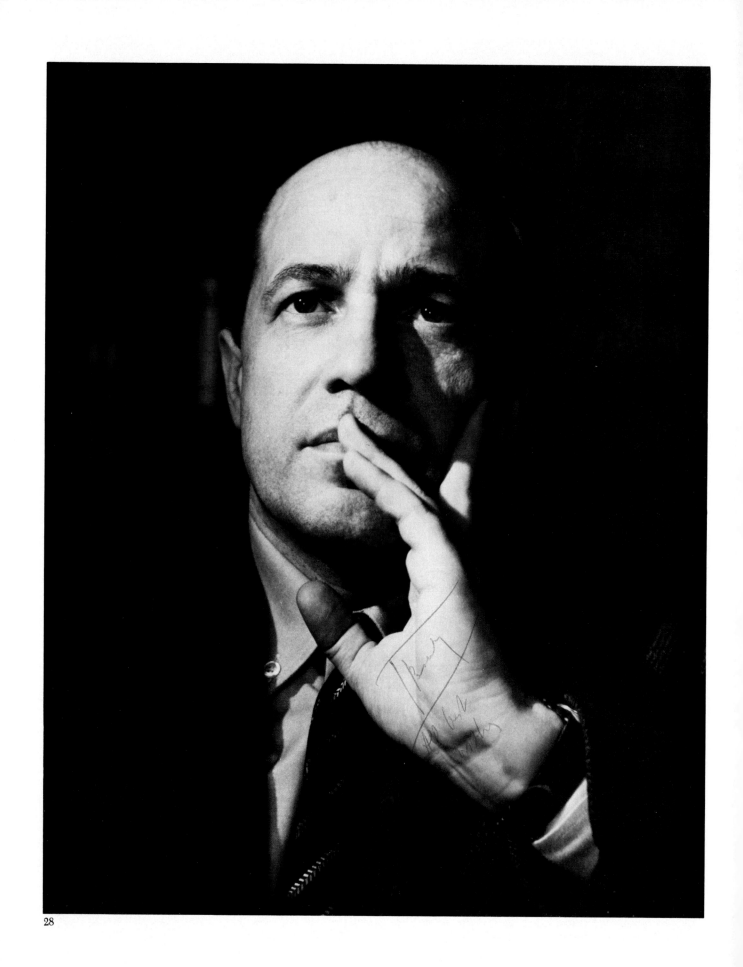

28

14

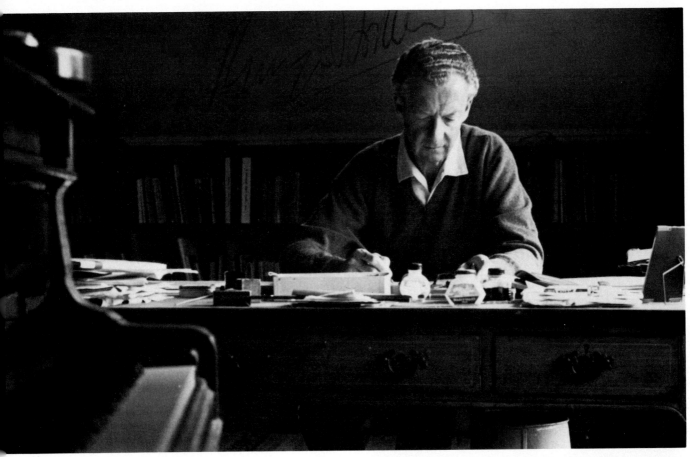

29

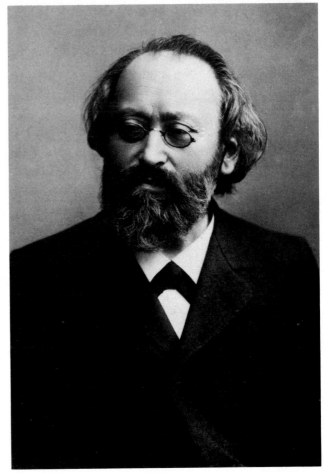

28. PIERRE BOULEZ (born 1925), French avant-garde composer also celebrated as a conductor. (Photo: Lotte Meitner-Graf, London.) 29. (SIR) BENJAMIN BRITTEN (1913–1976), English composer of operas and oratorios. His operas, which include *Peter Grimes* (1945) and *Billy Budd* (1951), have come the closest to achieving popular success of any classical operas since the last world war. 30. MAX BRUCH (1838–1920), German composer, especially famous for his *Kol Nidrei* for cello and orchestra, composed for the Liverpool Jewish community in 1880. He also wrote successful operas, a popular violin concerto in G minor and choral pieces.

30

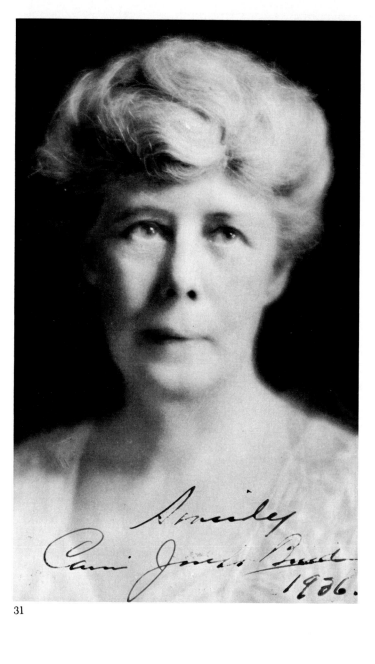

31

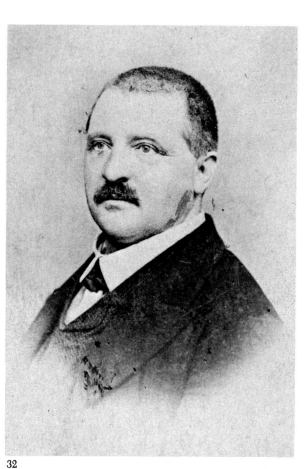

32

31. CARRIE JACOBS BOND (1862–1946), American composer of popular songs, among which "I Love You Truly" and "A Perfect Day" are outstanding. (Photo signed 1936.) 32. ANTON BRUCKNER (1824–1896), Austrian composer and organist. His compositions were attempts to duplicate Wagner's operatic theories in the field of symphonies. Recognition came slowly, but he is now regarded as one of the great composers. (Photo ca. 1868.) 33 & 34. JOHANNES BRAHMS (1833–1897), German. Brahms was venerated even in his own lifetime as one of the giant composers. His many great works include four symphonies, two piano concertos, the famous violin concerto in D, chamber music and lieder, all of the highest calibre. Von Bülow called him one of the three "B's," the others being Bach and Beethoven. (Photo 34: M. Frankenstein.)

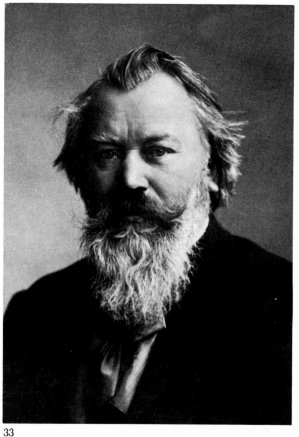

33

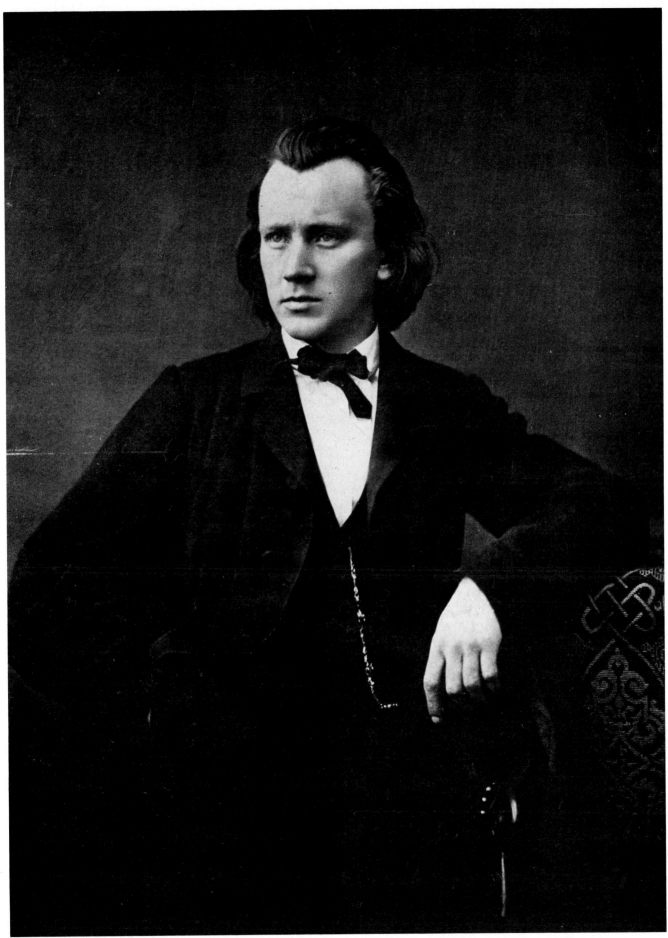

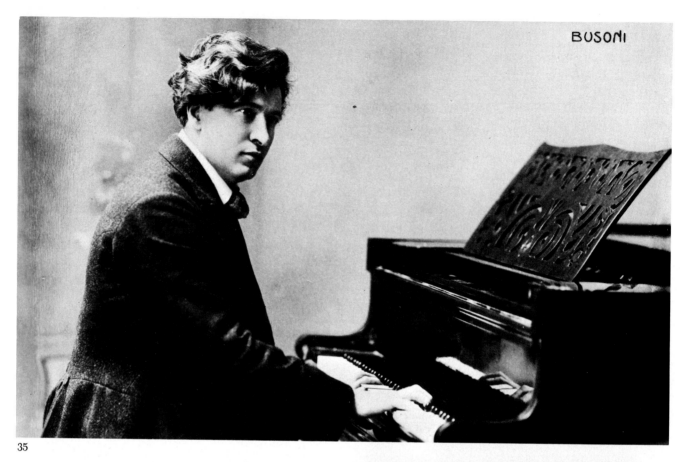

35

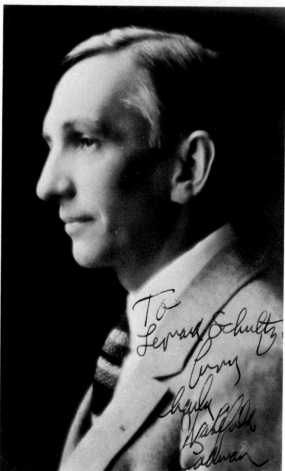

35. FERRUCCIO BUSONI (1866–1924), Italian composer and virtuoso pianist. Busoni mastered the entire range of composition, but his most famous works were the operas *Turandot* (1917) and the unfinished *Doktor Faust*. 36. CHARLES WAKE-FIELD CADMAN (1881–1946), American composer of operas, one of which was performed at the Metropolitan Opera (*Shanewis*, 1918). His most popular work was the song "At Dawning."

36

18

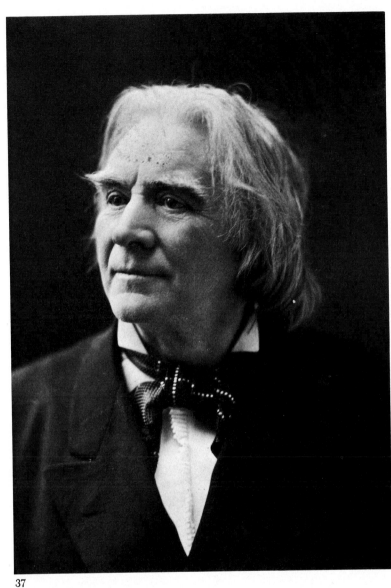

37

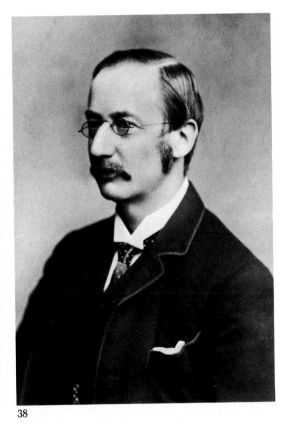

38

37. OLE BULL (1810–1880), Norwegian violinist who composed works on American subjects, including *Niagara, Solitude of the Prairies* and *To the Memory of Washington*. He had a successful career, especially in America, as a concert violinist. (Photo: Mora, N.Y.) 38. FRANK BRIDGE (1879–1941), English composer, teacher of Benjamin Britten. His works included symphonies, chamber music and many songs, which gained him his greatest fame.

39

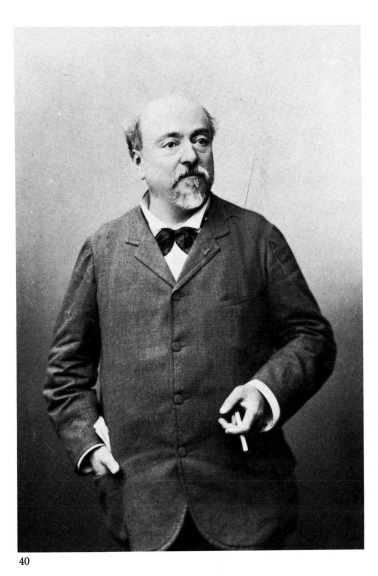

40

41

39. JOHN CAGE (born 1912), American composer, pupil of Schoenberg and Edgard Varèse. He has composed random music, silent music and works for a "prepared piano," with such foreign objects attached to the strings as screws, bolts, rubber bands, bamboo slivers and pins. (Photo: James Klosty.) 40. EMMANUEL CHABRIER (1841–1894), French symphonic and opera composer associated with Franck. His most successful opera was *Le roi malgré lui* (1887). (Photo: Benque, Paris.) 41. ELLIOTT CARTER (born 1908), American composer and music critic, highly acclaimed for idiomatic works in all vocal and instrumental genres, from opera and ballet to chamber music and piano pieces. (Photo 1976.)

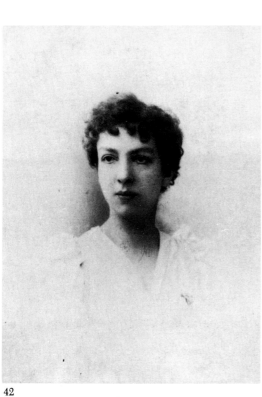

42

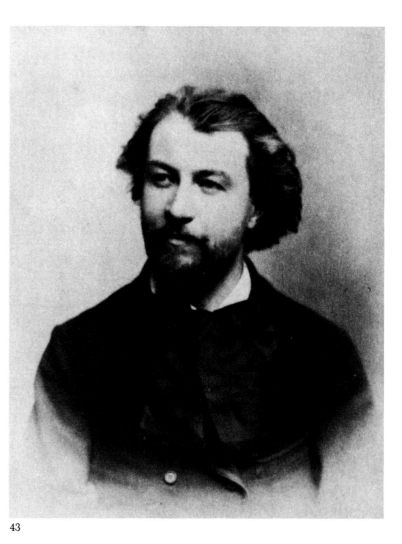

43

42. CÉCILE CHAMINADE (1857–1944), French composer and pianist. Noted for her salon pieces as well as hundreds of serious piano pieces, symphonic and chamber-music works. (Photo: P. Nadar, Paris.)
43. GUSTAVE CHARPENTIER (1860–1956), French composer. Of his many works, only one became noted, the opera *Louise* (1900). A sequel, *Julian*, was a failure despite the presence of Caruso and Farrar in the cast. (Photo: Bary, Paris.)

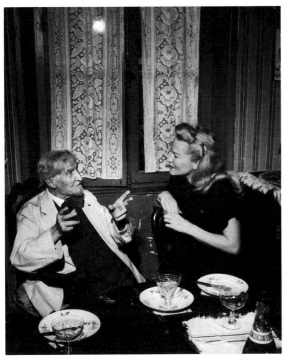

44

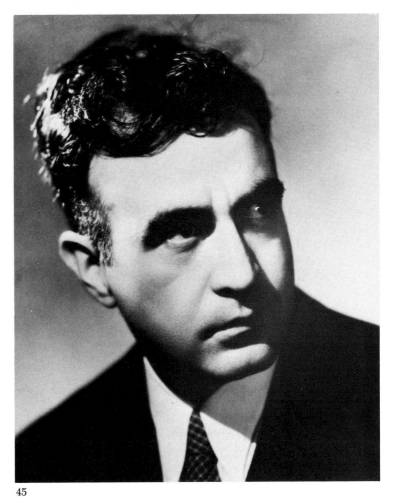

45

44. Charpentier in 1947 coaching Dorothy Kirsten, the last celebrated Louise, for her Paris debut in that role. 45. CARLOS CHÁVEZ (born 1899), Mexican composer whose works have utilized Mexican Indian folk themes. He has achieved world renown. (Photo: Toppo, N.Y., 1938.)

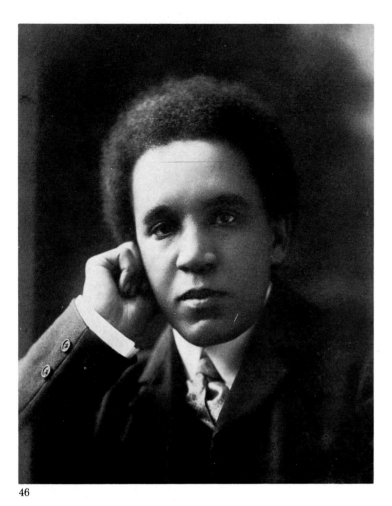

46

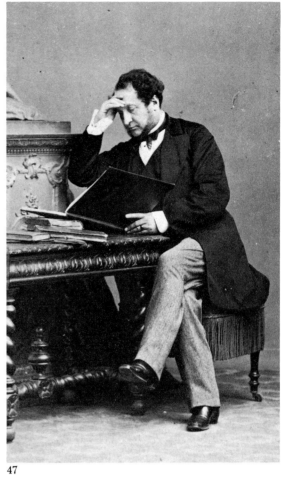

47

46. SAMUEL COLERIDGE-TAYLOR (1875–1912), British composer whose music was noted for its individuality. Wrote operas, choral pieces and symphonic and chamber works. 47. (SIR) MICHAEL COSTA (1806–1884), Italian conductor and composer active in England. His many operas include *Il sospetto funesto* and *Il delitto punito*. 48. (SIR) FREDERIC COWEN (1852–1935), British composer; pupil of Benedict, Moscheles and Reinecke. He composed a variety of works including operas, oratorios and symphonic pieces. (Photo: R. Thiele.) 49. AARON COPLAND (born 1900), the most celebrated American classical composer of the 20th century. His works include the ballets *Billy the Kid*, *Appalachian Spring* and *Rodeo*, and noted film scores. (Photo: Victor Kraft.)

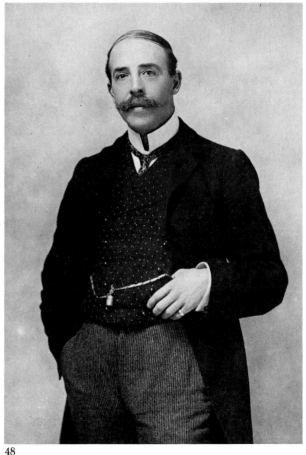

48

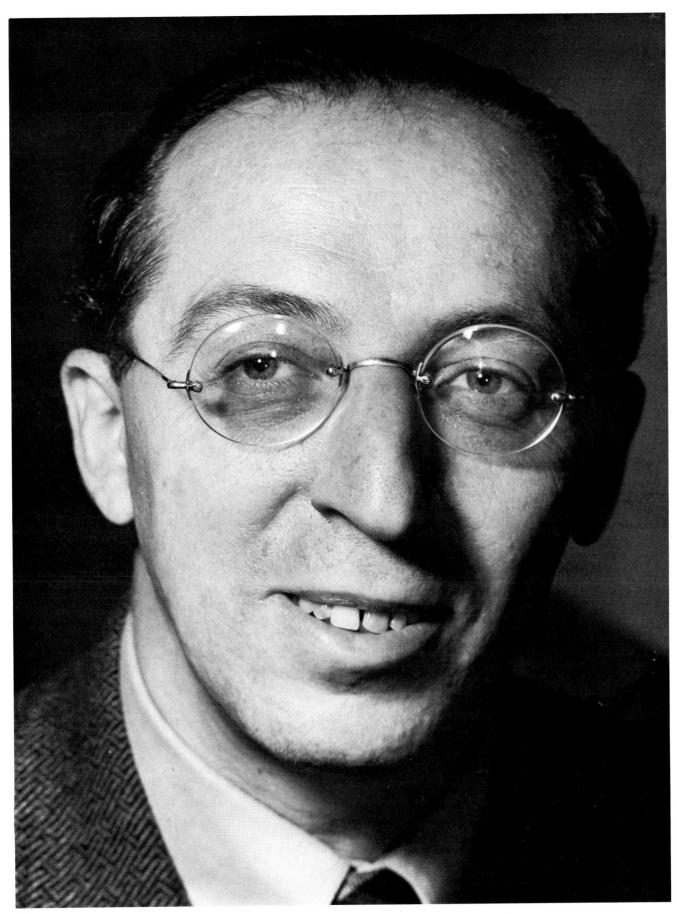

49

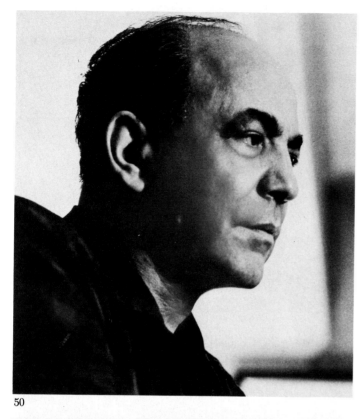

50

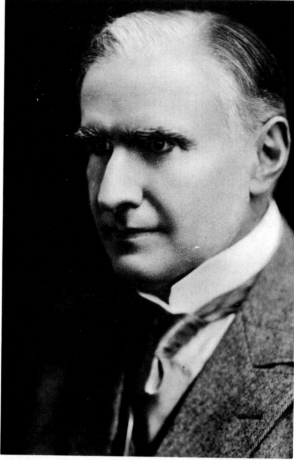

51

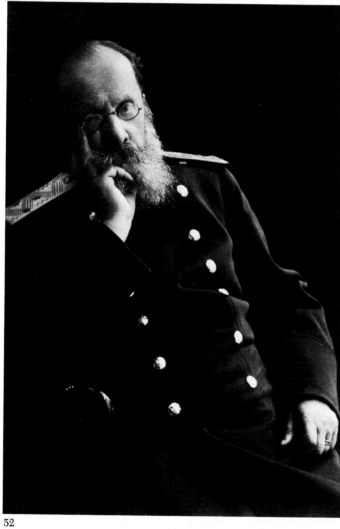

52

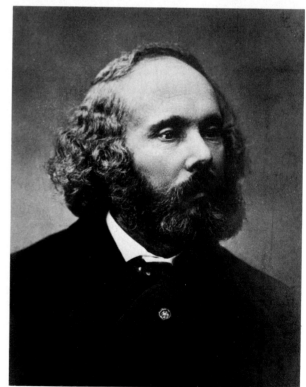

53

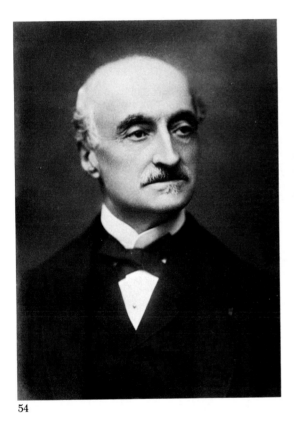

54

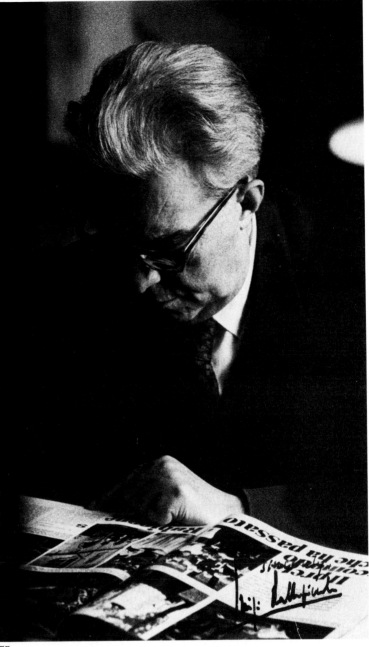

55

50. PAUL CRESTON (born 1906), American composer of symphonic and chamber works. (Photo signed 1973.) 51. WALTER DAMROSCH (1862–1950), German-born American composer and conductor. His operas *Cyrano de Bergerac* (1913) and *The Man Without a Country* (1937) were performed at the Metropolitan Opera. (Photo: Brown Brothers.) 52. CÉSAR CUI (1835–1918), Russian composer, member of the famous "Five." Noted in his lifetime for his six operas, especially *The Mandarin's Son* (1859), and many other works of a specifically Rus-sian nature. 53. FÉLICIEN DAVID (1810–1876), French opera composer, especially famous for *La perle du Brésil* and *Lalla Roukh*. He also composed works for cello and for piano. (Photo: Pierre Petit, Paris.) 54. CHARLES DANCLA (1817–1907), French composer and violinist. Among his more than 150 compositions were four symphonies and 14 string quartets. (Photo: Pierre Petit, Paris.) 55. LUIGI DALLAPICCOLA (born 1904), Italian modernist composer, noted for his employment of the "note-row."

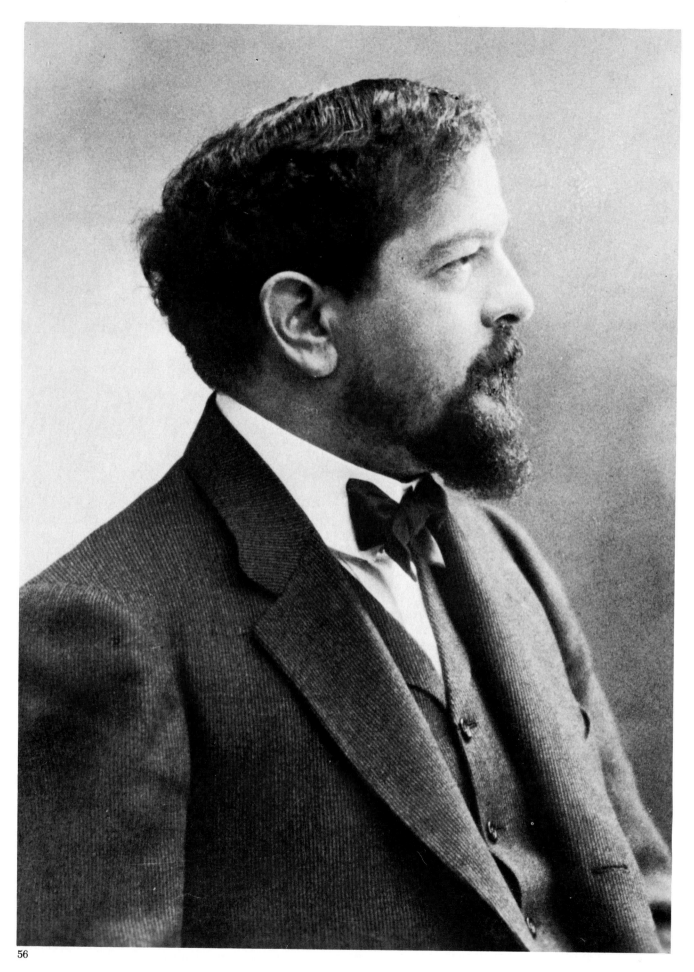

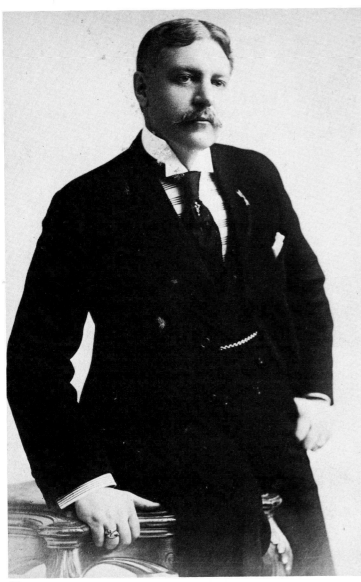

57

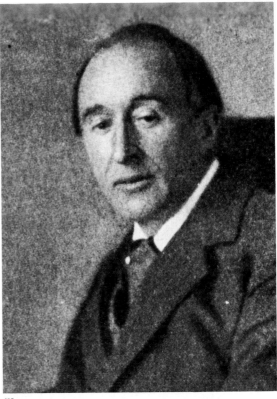

58

56. CLAUDE DEBUSSY (1862–1918), French composer. His "Impressionistic" compositions include the famous opera *Pelléas et Mélisande* and the symphonic poem *La Mer*. One of the basic composers in the history of writing for the piano, and probably the most important French composer of art songs. 57. REGINALD DE KOVEN (1859–1920), American composer who achieved notable success with operas, operettas and songs, of which "Oh, Promise Me" was most celebrated after its interpolation into his best light opera, *Robin Hood*. 58. FREDERICK DELIUS (1862–1934), English composer. His works included many symphonic pieces and such operas as *A Village Romeo and Juliet*. Sir Thomas Beecham was an early champion of his music, which is now being performed with increasing regularity. 59. (SIR) HENRY WALFORD DAVIES (1869–1941), English composer and organist who wrote both ecclesiastical and secular music.

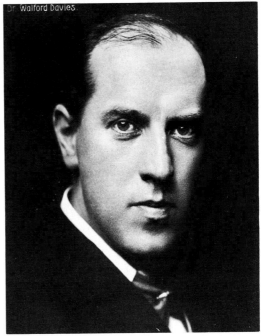

59

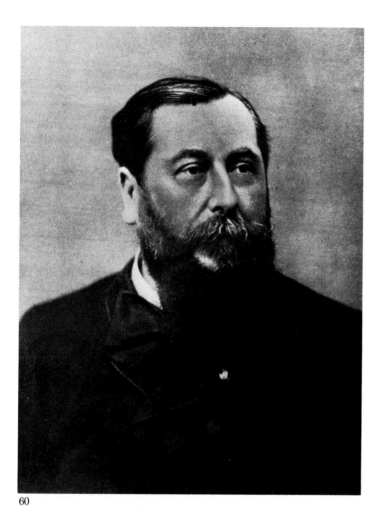

60

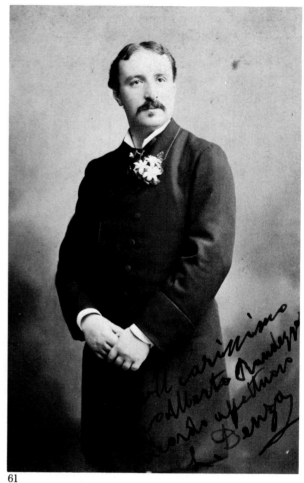

61

60. LÉO DELIBES (1836–1891), French composer noted for his ballets (notably *Coppélia* and *Sylvia*) and operas (especially *Lakmé*). 61. LUIGI DENZA (1846–1922), Italian song composer, student of Mercadante. His popular songs included the famous "Funiculì-Funiculà." (Photo: Alfred Ellis & Wallery, London.) 62 & 64. ERNST VON DOHNÁNYI (1877–1960), Hungarian composer and pianist. He composed many neo-Romantic works, including symphonies, piano concertos and operas. (Photo 62: E. Sandau, Berlin. Photo 64: Wide World Photos.) 63. DAVID DIAMOND (born 1915), American classical composer, student of Nadia Boulanger. His many works, which include symphonies, have been widely performed.

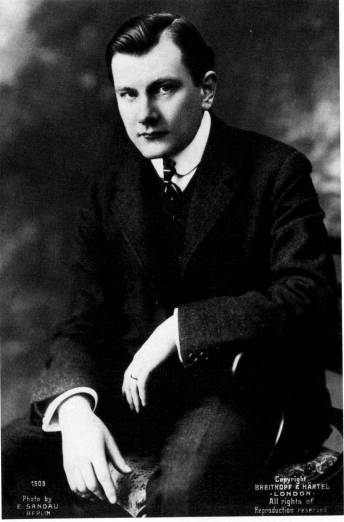

62

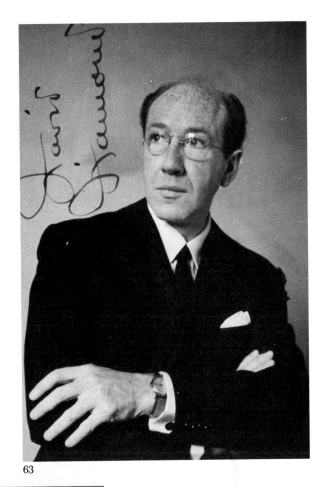

63

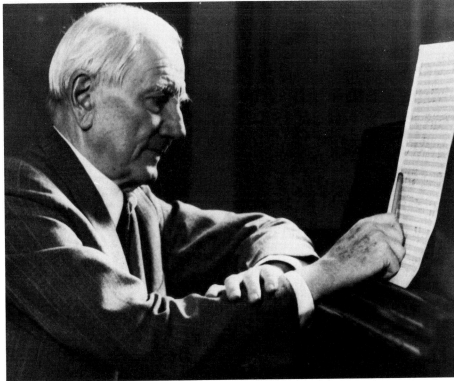

64

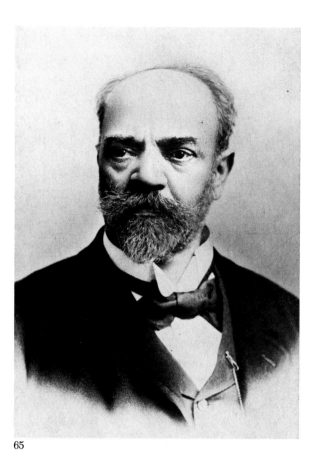

65

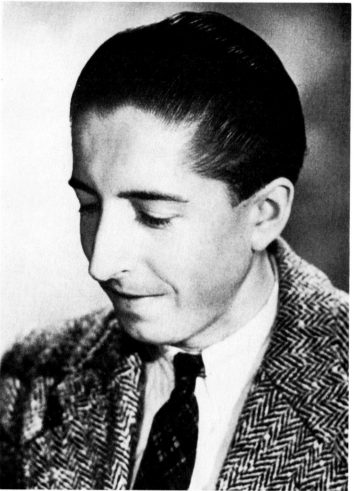

66

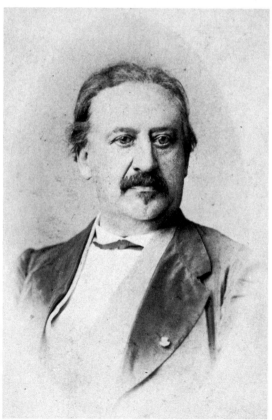

65 & 68. ANTONÍN DVOŘÁK (1841–1904), Bohemian composer, among the most celebrated of the 19th century. Like Smetana, he used folk themes of a national character, as in his famous opera *Rusalka*. He utilized American folk themes in the *New World Symphony*, which he composed while directing a conservatory in New York. 66. HENRI DUTILLEUX (born 1916), French composer of a noted symphony (1951) and other works of a neo-Impressionist-combined-with-modernist style. (Photo: Lipnitzki, Paris.) 67. FRIEDRICH VON FLOTOW (1812–1883), German composer of some 20 romantic operas, of which *Martha* is the best known. (Photo: Schrank & Massak, Vienna.)

67

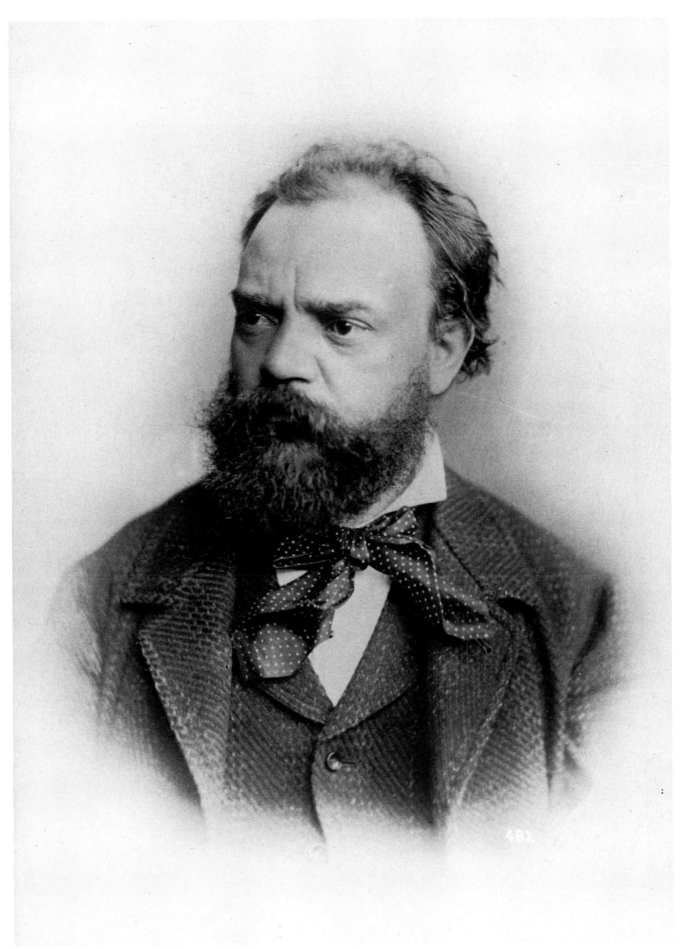

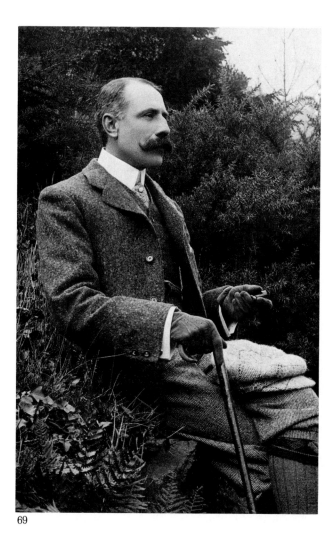

69

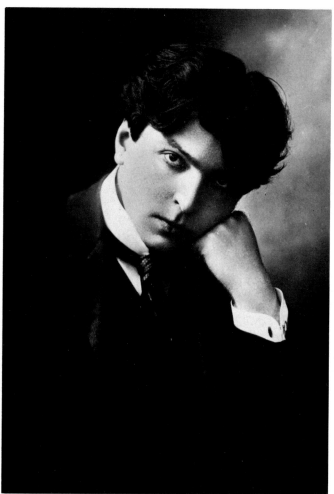

70

69. (SIR) EDWARD ELGAR (1857–1934), English composer now remembered mainly for his first *Pomp and Circumstance* march, written in connection with the coronation of Edward VII. Other notable compositions include the *Enigma Variations* and the oratorio *The Dream of Gerontius*.　70. GEORGES ENESCO (1881–1955), Rumanian composer of nationalistic works of a neo-Romantic nature. He was a noted violin virtuoso and teacher of Yehudi Menuhin, among others.

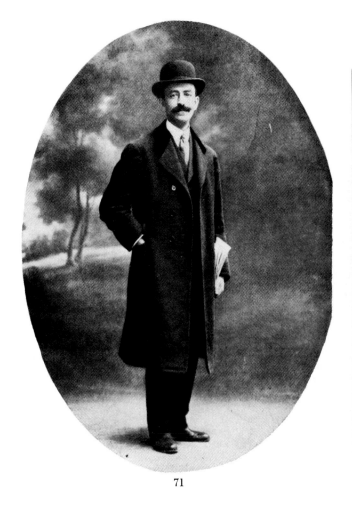

71

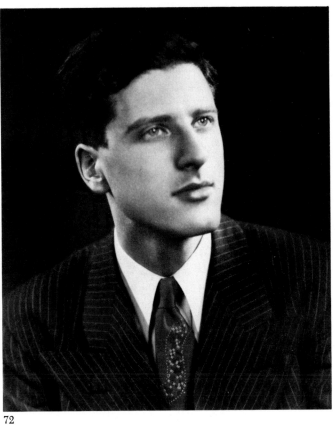

72

71. MANUEL DE FALLA, (1876–1946), Spanish composer. For Diaghilev he composed the ballet *The Three-Cornered Hat* in 1919. His opera *La Vida Breve* won a prize as best Spanish opera in 1905.

72. LUKAS FOSS (born 1922), German-born American composer of many ballets, songs, choral music, etc. Has tried to integrate some jazz principles of improvisation into performances of his music. Also a conductor.

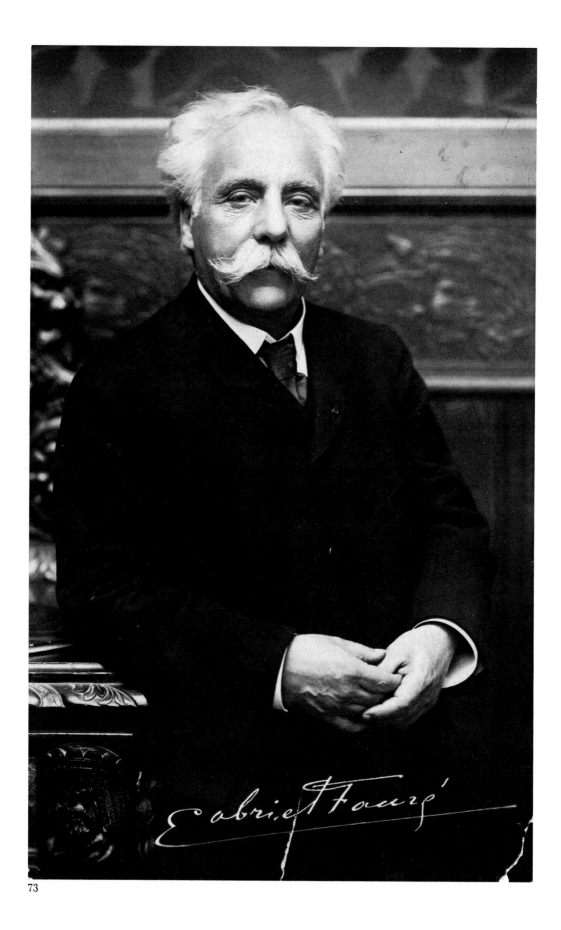

73

73. GABRIEL FAURÉ (1845–1924), French composer of operas, chamber music, songs and orchestral music. His pupils included Ravel and Enesco.

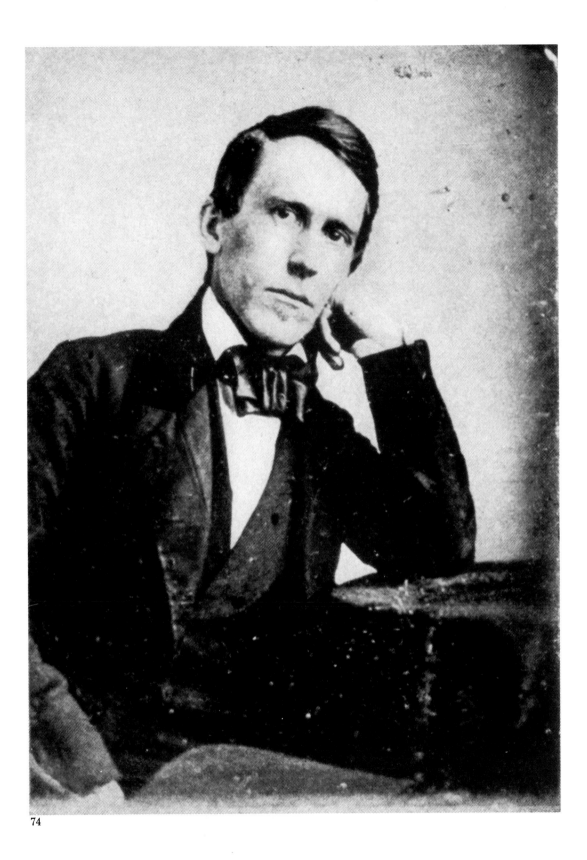

74

74. STEPHEN FOSTER (1826–1864), American composer of songs and ballads. The most celebrated writer of music in 19th-century America, he has been called the "American Schubert" for the sentimental and haunting quality of many of his songs, which include "Old Folks at Home," "Jeanie with the Light Brown Hair" and "My Old Kentucky Home." (Photo ca. 1859.)

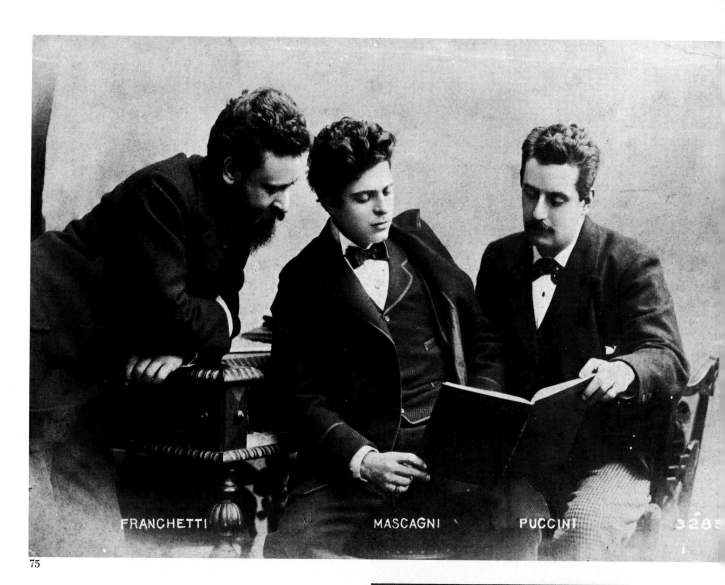

FRANCHETTI MASCAGNI PUCCINI

75

75. ALBERTO FRANCHETTI (1860–1942), Italian opera composer of the *verismo* school, best remembered for his 1902 *Germania*. He is shown here with Mascagni (see No. 140) and Puccini (see No. 167). 76. ARTHUR FOOTE (1853–1937), American composer whose works are enjoying a revival. (Photo ca. 1911.) 77. CÉSAR FRANCK (1822–1890), Belgian composer and organist active in France. Franck is today highly regarded as a symphonic composer, but he had true public success only in the last month of his life. His *Symphony* is now a concert staple.

76

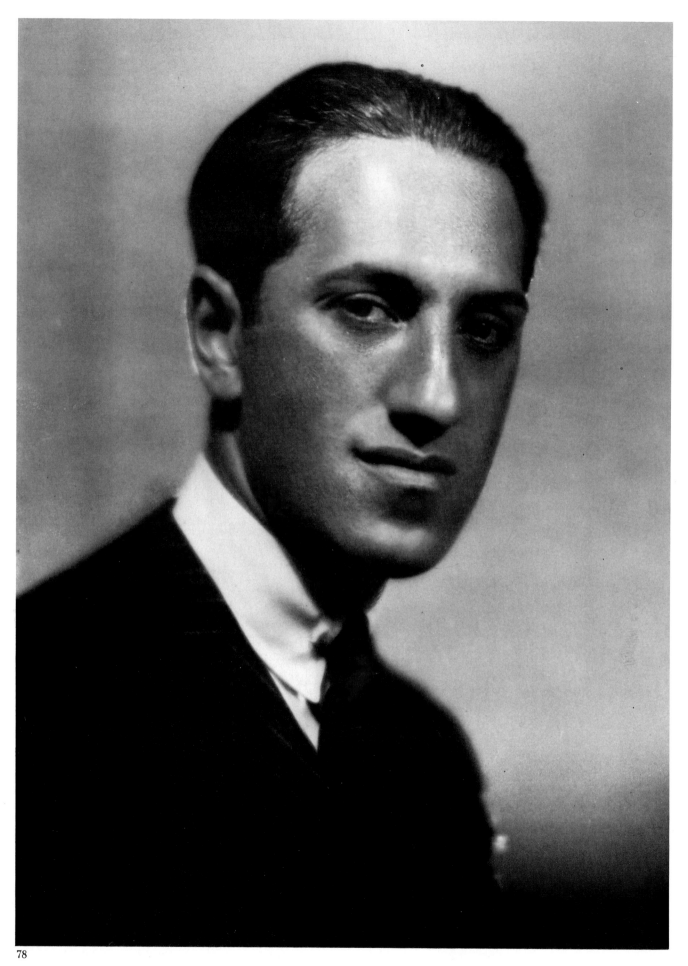

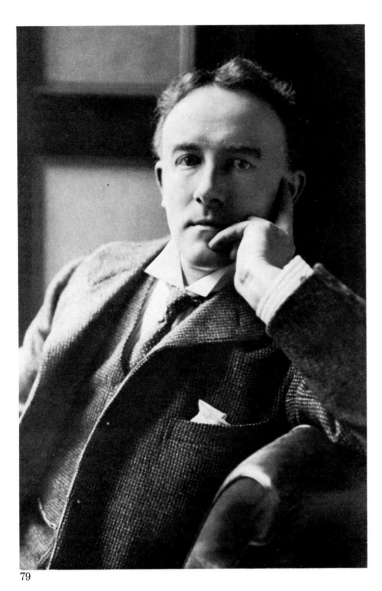

79

80

78. GEORGE GERSHWIN (1898–1937), American composer. Gershwin's success both in popular and "serious" music made him perhaps America's most widely known composer of the 20th century. Classical works include his opera *Porgy and Bess*, the *Rhapsody in Blue* and *An American in Paris*. (Photo: Maurice Goldberg.) 79. (SIR) EDWARD GERMAN (1862–1936), English composer of light operas, the most famous being *Merrie England*. (Photo: R. J. W. Haines.) 80. ROBERT FRANZ (1815–1892), German composer of some 350 songs. He was admired by Schumann, Mendelssohn and Liszt, among others. 81. RUDOLF FRIML (1879–1972), Czechborn American composer of operettas, including the famous *The Firefly* and *Rose-Marie*.

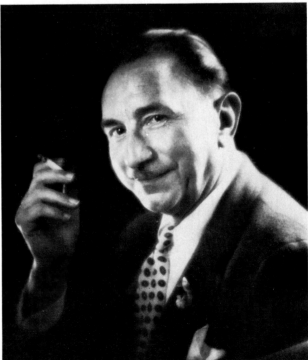

81

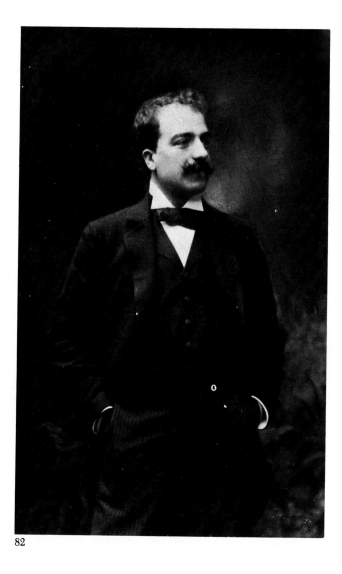

82

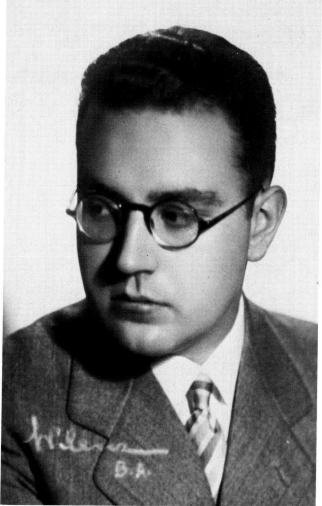

83

82. UMBERTO GIORDANO (1867–1948), Italian composer of *verismo* operas. His masterpieces were *Andrea Chénier* and *Fedora*, both of which have held the stages of the world's opera houses to this day.

83. ALBERTO GINASTERA (born 1916), Argentinian composer. His opera *Bomarzo* has achieved some notoriety mostly because of its subject.

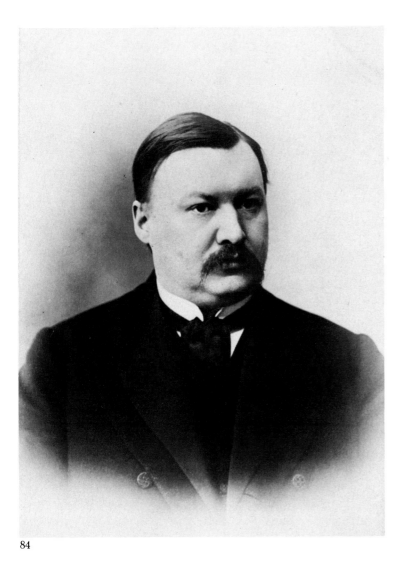

84

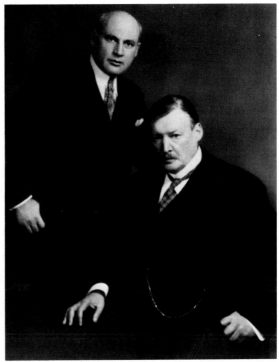

85

84 & 85. ALEXANDER GLAZUNOV (1865–1936), Russian composer, chiefly of symphonic music. His ballets, such as *Raymonda*, were especially popular.

In No. 85 he is seen with the famous impresario Sol Hurok.

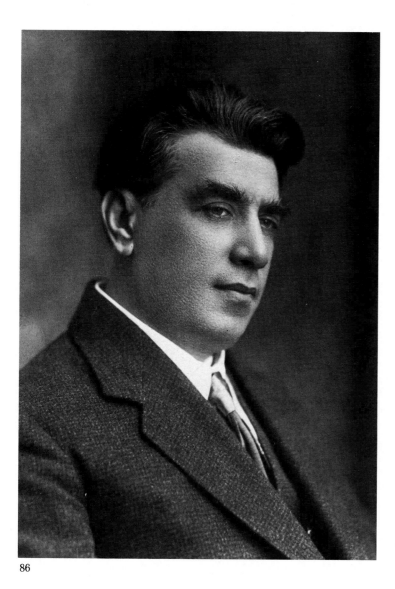

86

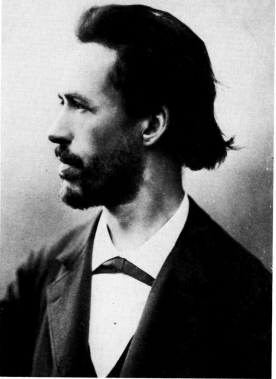

87

86. REINHOLD GLIÈRE (1875–1976), Russian composer, pupil of Ippolitov-Ivanov. Composed many successful works, including symphonies, tone poems, an opera and ballets (especially *The Red Poppy*). (Photo signed Moscow, 1928.)　87. BENJAMIN GODARD (1849–1895), French composer of popular operas, a violin concerto, symphonies and songs. His best-known composition is the "Berceuse" from his opera *Jocelyn*. (Photo: Geruzet Frères, Brussels.) 88. MIKHAIL GLINKA (1804–1857), Russian composer known as "the Father of the Russian National School." His romantic operas *A Life for the Tsar (Ivan Susanin)* and *Ruslan and Ludmila* have become imperishable classics in Russia.

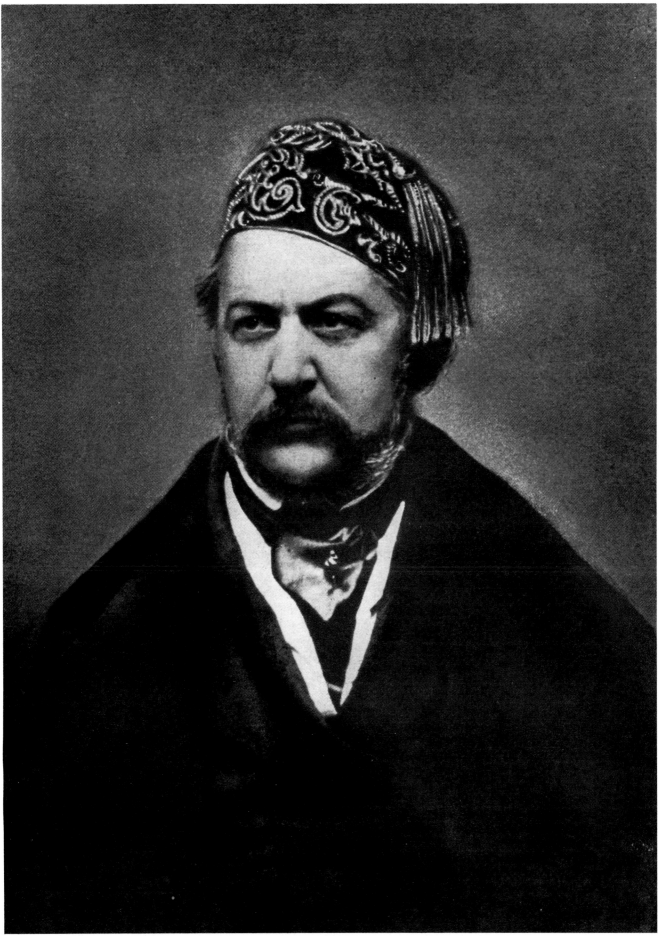

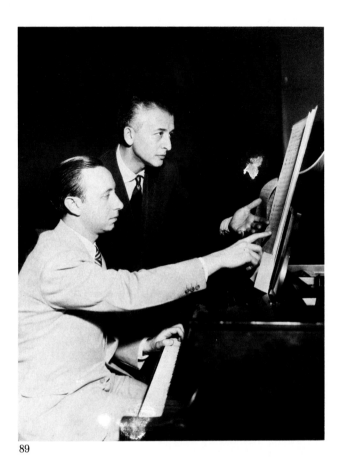

89

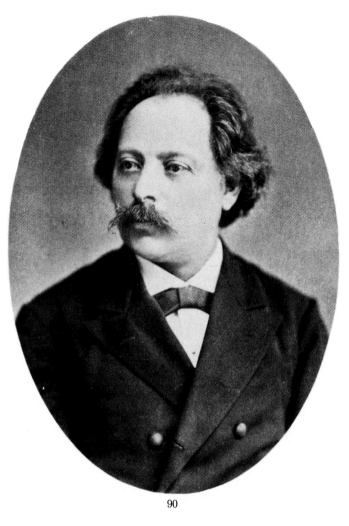

90

89. MORTON GOULD (born 1913), American composer especially known for his 1948 ballet *Fall River Legend* and *Latin American Symphonette*. Standing next to him in the photo is conductor Vladimir Golschmann. (Photo 1944, in connection with the premiere of *Symphony on Marching Tunes.*) 90.

KARL GOLDMARK (1830–1915), Hungarian composer active in Vienna. Wrote operas, orchestral and chamber music, etc. His opera *The Queen of Sheba* and his *Rustic Wedding Symphony* are still performed. (Photo: J. Löwy, Vienna.)

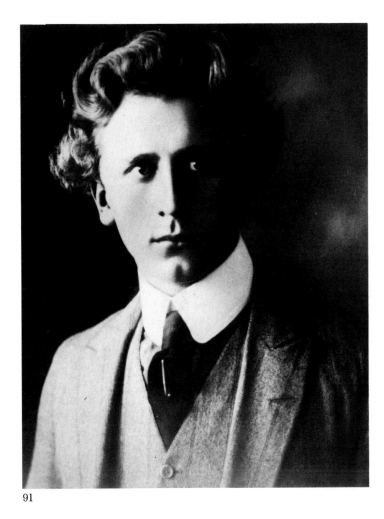

91

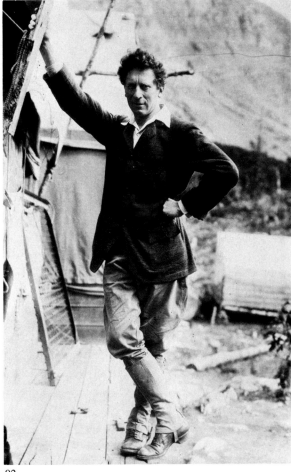

92

91 & 92. PERCY ALDRIDGE GRAINGER (1822–1961), Australian pianist and composer. A protégé of Grieg, Grainger nevertheless was strikingly individual in his compositions, which are often based on old English and Irish folk songs, sometimes using experimental scoring. (Photo 92: Underwood & Underwood.)

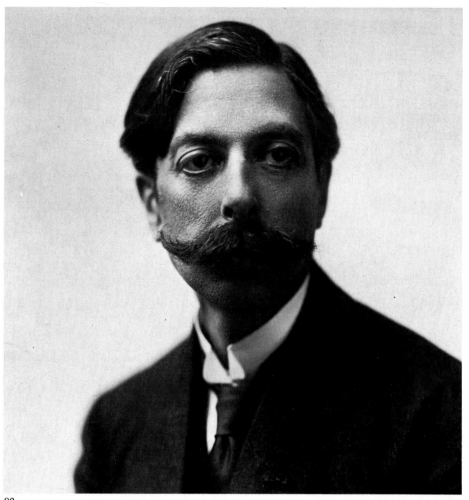

93

93. ENRIQUE GRANADOS (1867–1916), Spanish composer, especially celebrated for music inspired by the painter Goya. These *Goyescas*, originally composed as piano pieces, were later adapted into an opera of the same name which was successfully produced at the Met in 1916. Shortly afterward the composer went down with a torpedoed ship. 94. LOUIS MOREAU GOTTSCHALK (1829–1869), American composer and pianist. His compositions reflect the Creole traditions of New Orleans, having both Spanish and French influences. He composed two operas, symphonic poems and many works for solo piano which are now being revived. He had an outstanding career as a touring piano virtuoso.

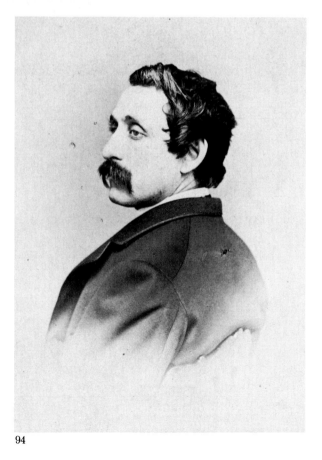

94

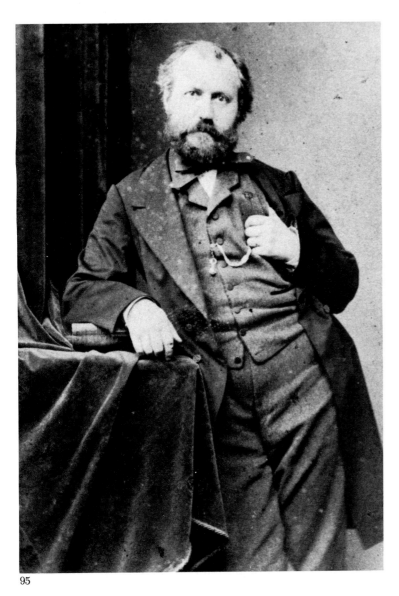

95

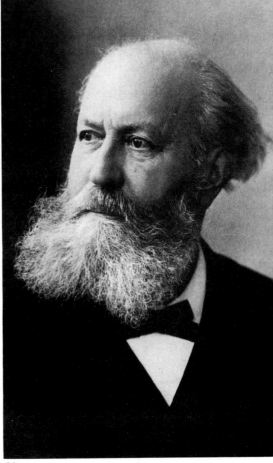

96

95 & 96. CHARLES GOUNOD (1818–1893), French opera composer, also well known for his symphonic *Funeral March of a Marionette*. His operas *Faust* and *Romeo and Juliet* were the most popular operas of the second half of the 19th century, but the current decline in French singing traditions has brought a temporary eclipse. Gounod enjoyed veneration in France in his lifetime similar to that accorded Brahms in Germany and Austria.

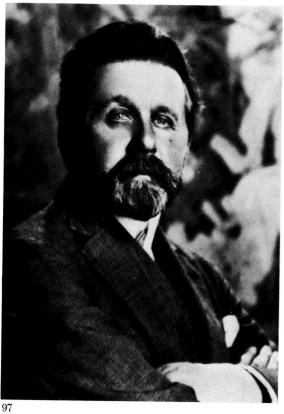

97

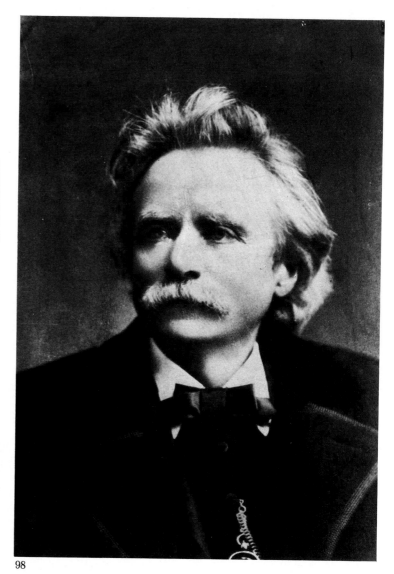

98

97. ALEXANDER GRETCHANINOV (1864–1956), Russian composer, student of Arensky and Rimsky-Korsakov. His compositions were very successful in the United States and in 1946 he became an American citizen. His sacred vocal compositions remain highly regarded. (Photo: Lipnitzki, Paris.) 98. EDVARD GRIEG (1843–1907), Norwegian composer. One of the most famous composers of the 19th century, he is especially renowned for his music for Ibsen's play *Peer Gynt,* and for his piano concerto, one of the most popular ever written. 99. FERDE (Ferdinand) GROFÉ (1892–1972), American composer. Grofé first became prominent as an arranger for Paul Whiteman. His many orchestral compositions include the *Grand Canyon Suite* and the *Hollywood Suite.* 100. COR DE GROOT (born 1914), Dutch pianist and composer of many works, including the ballet *Vernissage* (1941). (Photo: Cor van Weele.) 101. HENRY HADLEY (1871–1937), American composer. Hadley became one of the most celebrated American composers of his time. He composed in a neo-Romantic vein many programmatic works and a number of operas, including *Cleopatra's Night,* produced at the Metropolitan Opera in 1920.

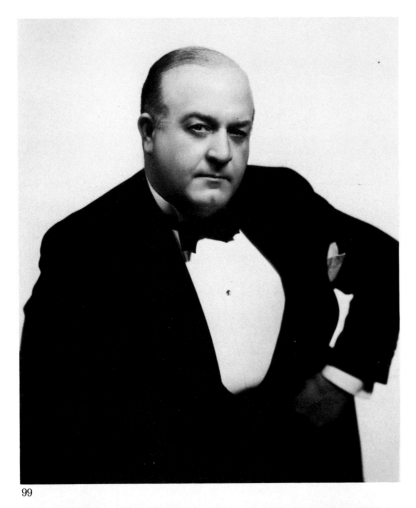

99

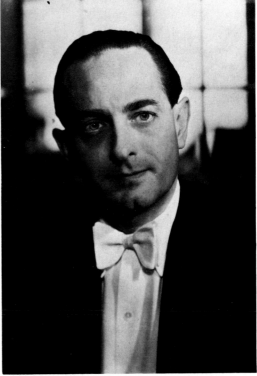

100

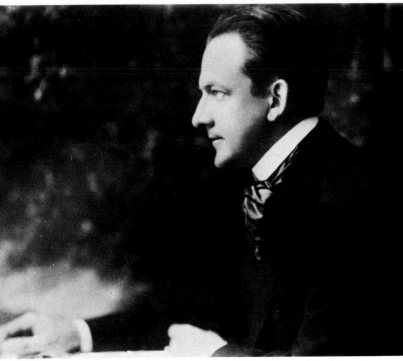

101

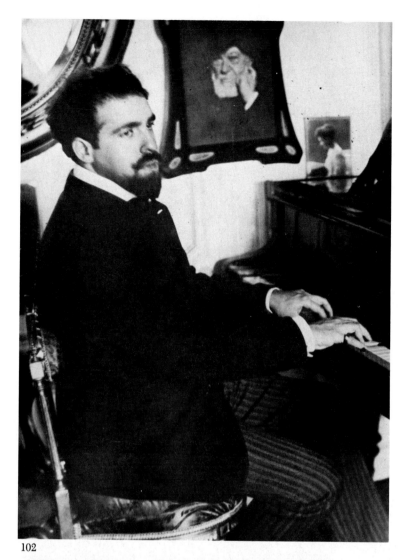

102

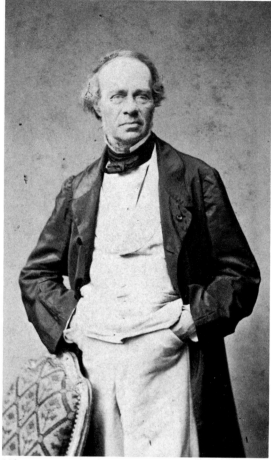

103

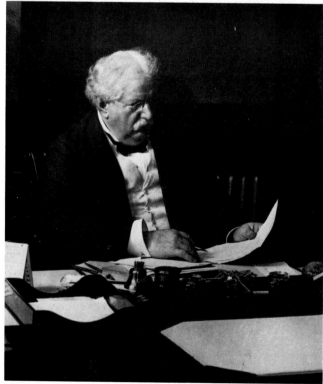

104

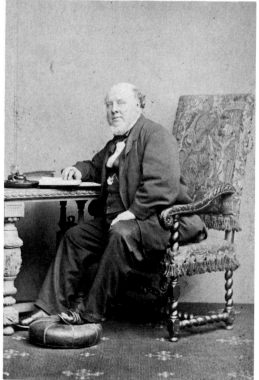

105

52

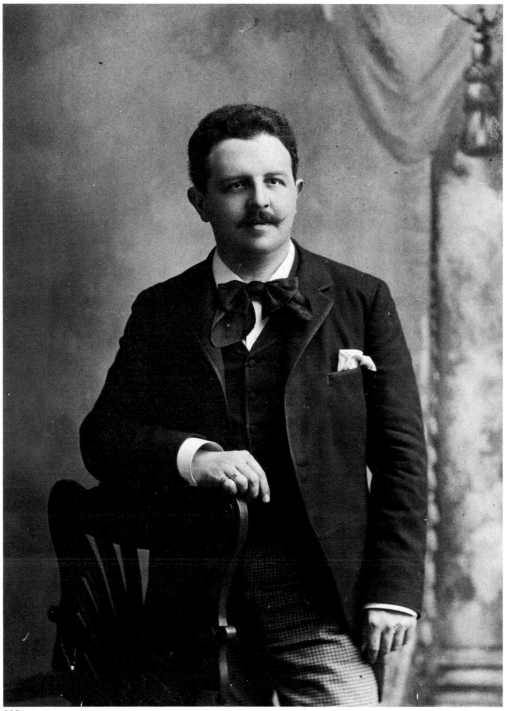

106

102. REYNALDO HAHN (1875–1947), Venezuela-born French composer. Hahn was especially noted for his vocal music; some of his songs and operettas became very popular. He was also famous as a Mozart conductor. (Photo: Underwood & Underwood.) 103. FROMENTAL HALÉVY (1799–1862), French composer, student of Cherubini. Halévy was a pillar of French grand opera, becoming especially famous for his *La Juive*, a revival of which opened the present Paris Opera House. His nephew Ludovic Halévy wrote outstanding librettos for Offenbach. (Photo: Pierre Petit, Paris.) 104 & 106. VICTOR HERBERT (1859–1924), Irish-born American com-

poser, educated in Germany. Herbert, also a noted cellist and conductor, was an enormously successful composer of operettas such as *Babes in Toyland*, *Mlle. Modiste*, *The Red Mill*, and *Naughty Marietta*. He also composed many instrumental pieces and grand operas (including *Natoma*) without achieving the success of his lighter music. (Photo 104: Pach Bros., N.Y. Photo 106: George H. Van Norman.) 105. JOHN LIPTROT HATTON (1809–1886), British composer, mainly of light operas and songs, the most famous of which was "Good-bye, Sweetheart, Good-bye." (Photo: Moira & Haigh, London.)

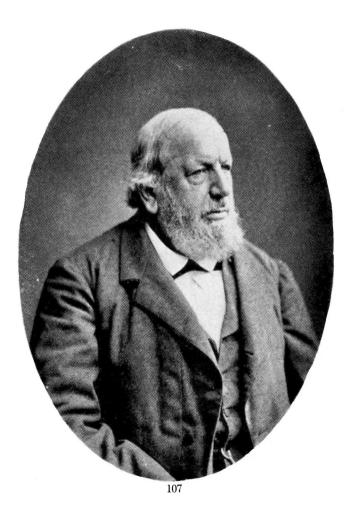

107

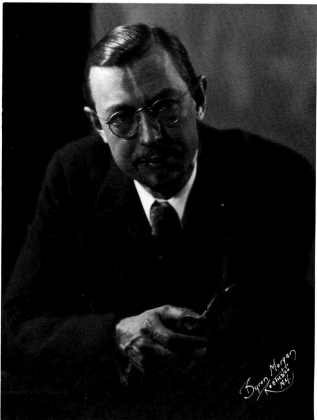

108

107. FERDINAND HILLER (1811–1885), German composer and conductor, student of Hummel. A friend of Chopin, Liszt and other celebrated Romantic composers, he was noted for his operas and piano concertos, which are now being revived. He composed many symphonic and chamber works as well, and was an important pianist and conductor. (Photo: Eilender, Cologne.) 108. HOWARD HANSON (born 1896), American composer. Hanson's opera *Merry Mount* was commissioned by the Metropolitan Opera and produced there in 1934. His many works were written in a post-Romantic vein. He was later very active at the Eastman School of Music in Rochester, N.Y. (Photo: Byron Morgan, Rochester.)

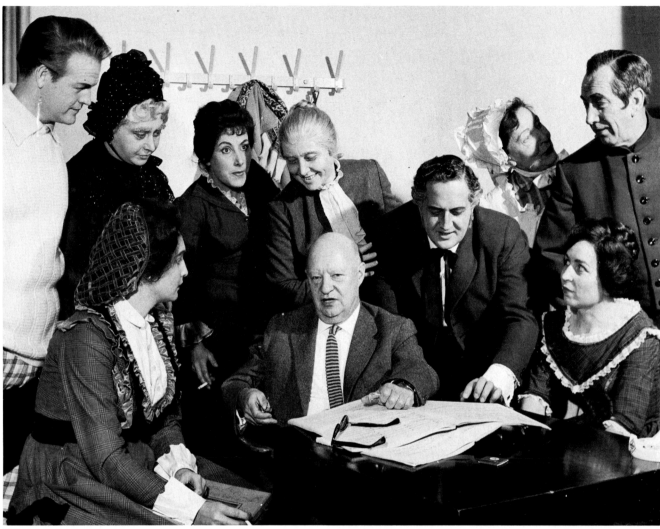

109

109. PAUL HINDEMITH (1895–1963), German composer, champion of "Gebrauchsmusik." One of the most successful modernists, Hindemith composed the opera *Mathis der Maler* and many other highly admired works. He was a violinist and violist and played in a celebrated quartet. In the photo he is seen with members of the Mannheim Opera on the occasion of the 1961 production of his opera *The Long Christmas Dinner*. See also No. 211.

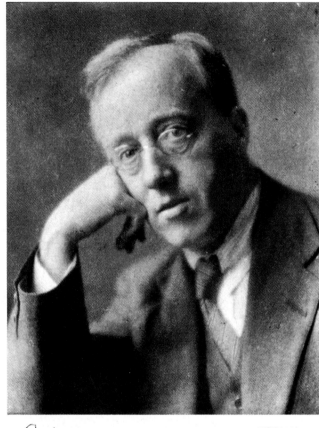

110

111

110. ARTHUR HONEGGER (1892–1955), Swiss/
French composer, member of "Les Six." Honegger
composed a variety of works including operas,
ballets, oratorios and orchestral and chamber music.
(Photo: G. L. Manuel Frères.) 111. GUSTAV

HOLST (1874–1934), British composer known
primarily for his orchestral suite *The Planets*, first
performed in 1918. He also composed operas and
other instrumental music.

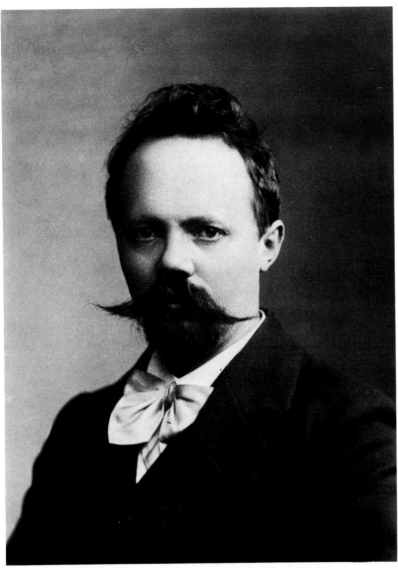

112

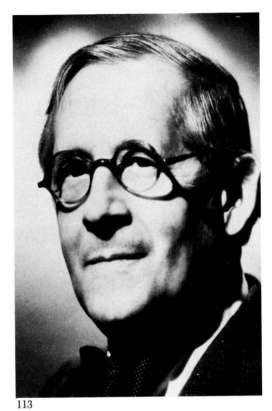

113

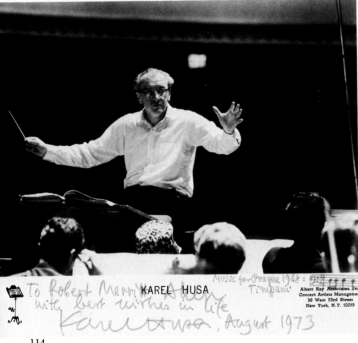

KAREL HUSA

To Robert Merrill with best wishes in life
Karel Husa, August 1973

Music for Prague 1968
Timpani

Albert Kay Associates, Inc.
Concert Artists Management
58 West 53rd Street
New York, N.Y. 10019

114

112. ENGELBERT HUMPERDINCK (1854–1921), German composer, disciple of Wagner. His opera *Hansel and Gretel* has become a classic. *Königskinder*, which had a brilliant Met premiere in 1910, is another example of his operas, all written in a melodic, but Wagnerian vein. He was also a brilliant music critic. 113. DÉSIRÉ INGHELBRECHT (1880–1956), French composer and conductor. He composed a variety of music and wrote a book called *The Conductor's World*. (Photo: Lipnitzki, Paris.) 114. KAREL HUSA (born 1921), Czech composer, student of Honegger and Nadia Boulanger. Husa has been active as a composer in the United States, writing many works of varied character.

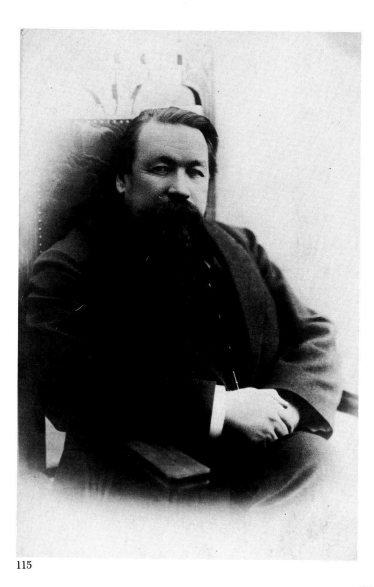

115

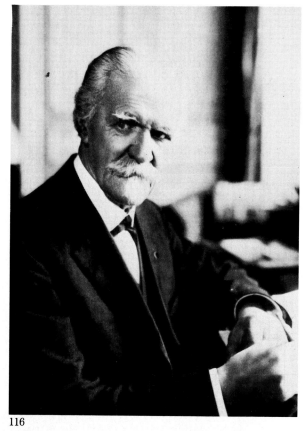

116

115. MIKHAIL IPPOLITOV-IVANOV (1859–1935), Russian composer, student of Rimsky-Korsakov. His deep interest in Asian music is reflected in his celebrated *Caucasian Sketches* written in 1895. He was also a composer and conductor of opera. 116 & 118. VINCENT D'INDY (1851–1931), French composer of many academically written works after the manner of Franck. Co-founder of the Schola Cantorum music school. (Photo 116: Henri Manuel.) 117. CHARLES EDWARD IVES (1874–1954), American composer of nationalistic works of a highly complex nature.

117

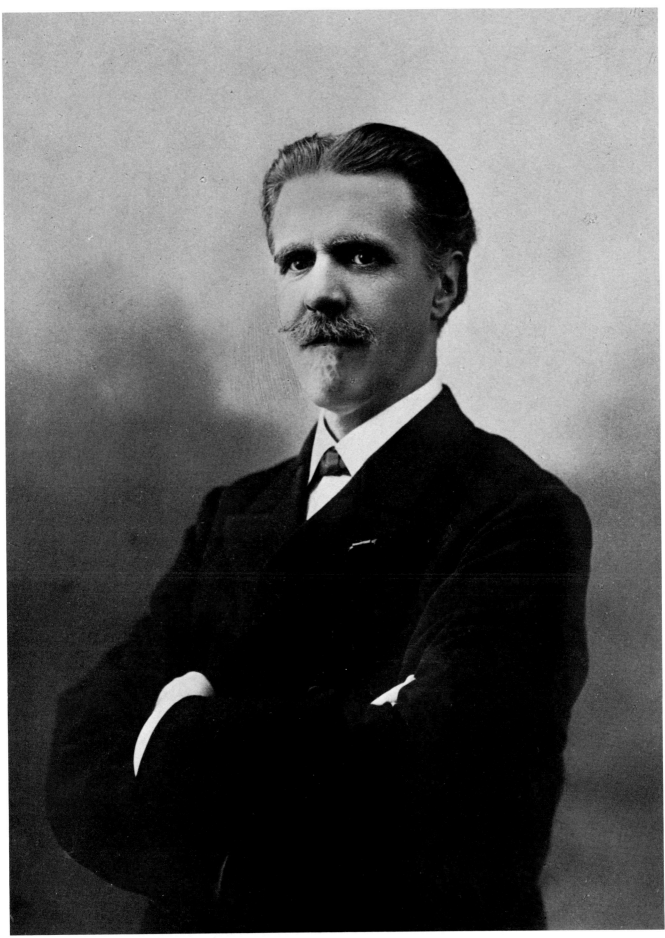

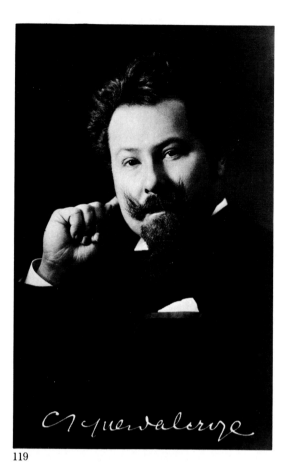

119

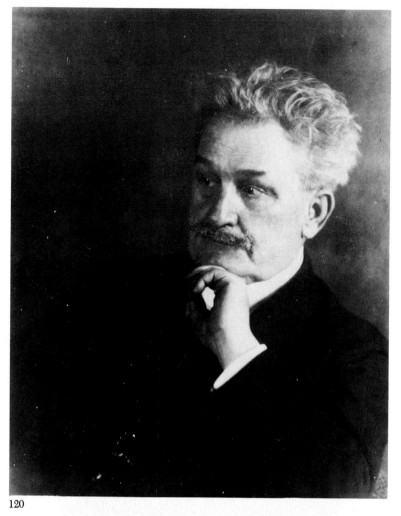

120

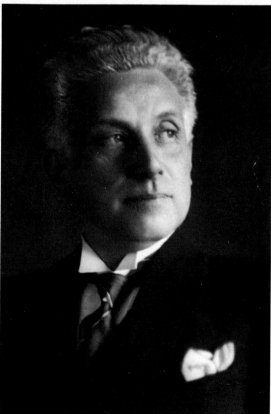

121

119. EMILE JAQUES-DALCROZE (1865–1950), French/Austrian composer, chiefly active in Switzerland and Germany. Inventor of "Eurhythmics," a system of musical training through movement. He also composed many successful songs and operas.
120. LEOŠ JANÁČEK (1854–1928), Czech composer of many operas of a nationalistic flavor, of which *Jenufa* and *Kat'a Kabanová* are notable examples.
121. LEON JESSEL (1871–1942), German composer of operettas of considerable popularity, including *Schwarzwaldmädel* and *Des Königs Nachbarin*.

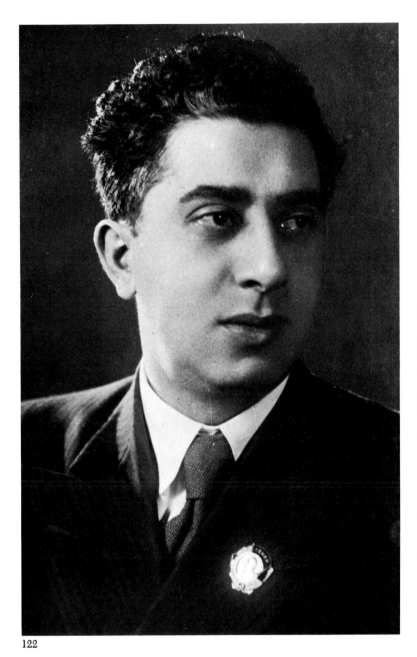

122

123

122. ARAM KHACHATURIAN (born 1903), Russian-Armenian composer of music based largely on folk idioms. A popular composer of ballets and symphonic works. 123. ANDRÉ JOLIVET (born 1905). French composer. Formed a group called "La Jeune France" with Messiaen, Daniel Lesur and Yves Baudrier to promote their modern compositions. He has composed a variety of works.

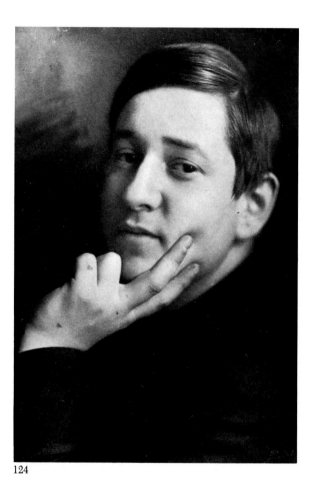

124

125

124. ERICH WOLFGANG KORNGOLD (1897–1957), Austrian composer born in Moravia. A prodigy as an opera composer — with *Die tote Stadt*, produced in 1920 — he became even more successful as an Academy Award-winning film composer for *The Adventures of Robin Hood, The Sea Hawk, Kings* *Row*, etc. He lived in California from 1935 on. (Photo: Rudolf Dührkop; signed Vienna, 1918).

125. ZOLTÁN KODÁLY (1882–1967), Hungarian composer. His compositions were nationalistic in character and he compiled and adapted many folk tunes.

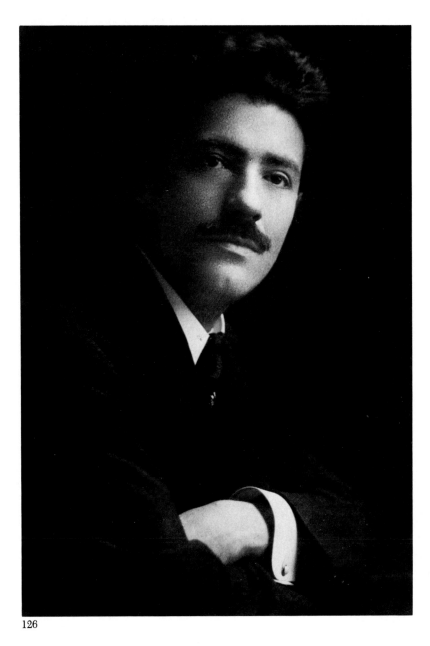

126

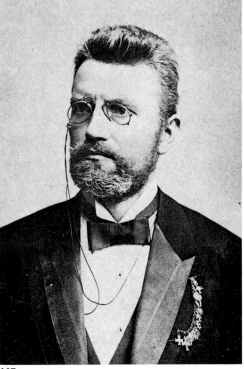

127

126. FRITZ KREISLER (1875–1962), Austrian violinist and composer. A supreme violinist, he was also a noted composer of small-scale songs and violin works, some of which he originally introduced as rediscovered works by 18th-century composers.

127. KAREL KOMZÁK (1823–1893), Czech composer and organist. He composed over two hundred popular marches, dances, etc.

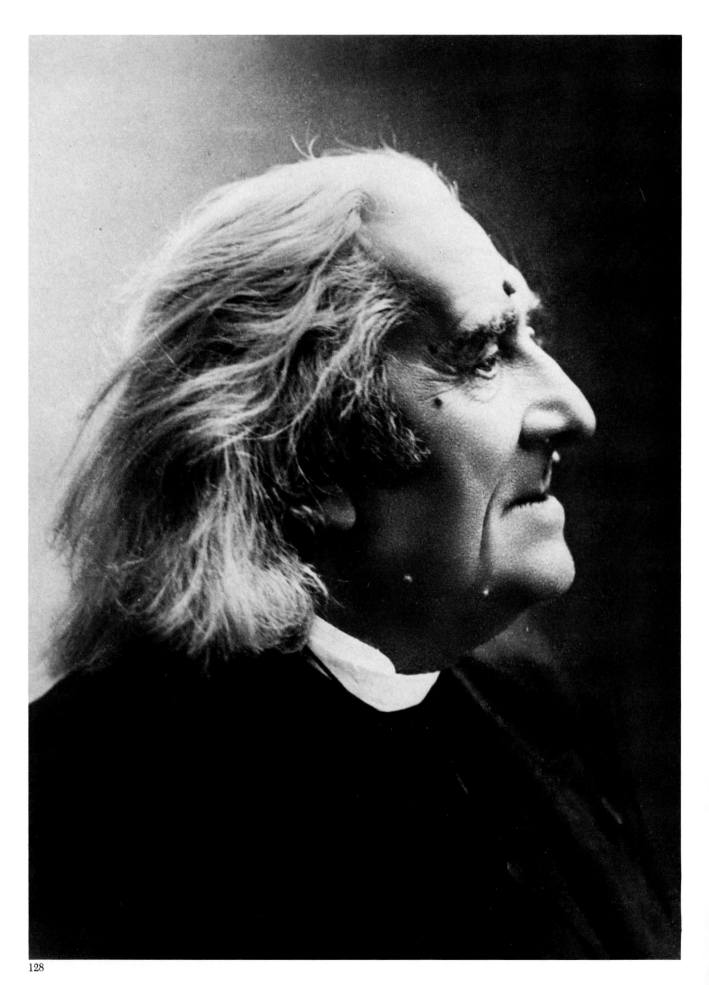

128

64

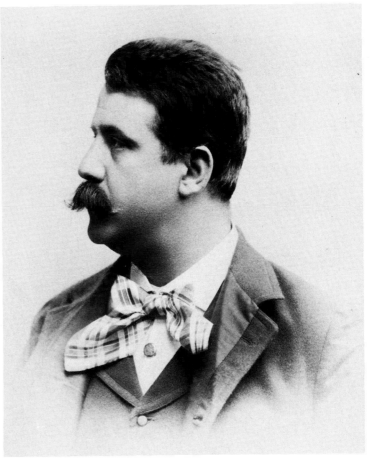

129

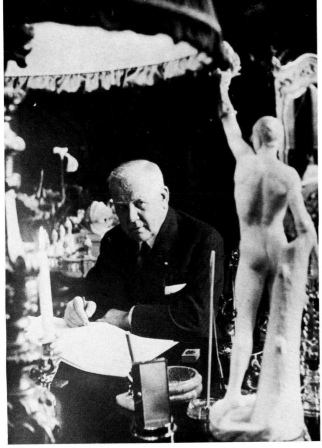

130

128. FRANZ (Ferenc) LISZT (1811–1886), Hungarian pianist and composer. The premier pianist of the 19th century, Liszt wrote wildly romantic solo piano music, two concertos and many transcriptions for piano of other composers' music. He is credited with devising the "symphonic poem." 129. RUGGIERO LEONCAVALLO (1858–1919), Italian opera composer chiefly remembered for his popular two-act opera *I Pagliacci*. 130. FRANZ LEHÁR (1870–1948), Hungarian-born Austrian composer of enormously popular operettas, especially *The Merry Widow*.

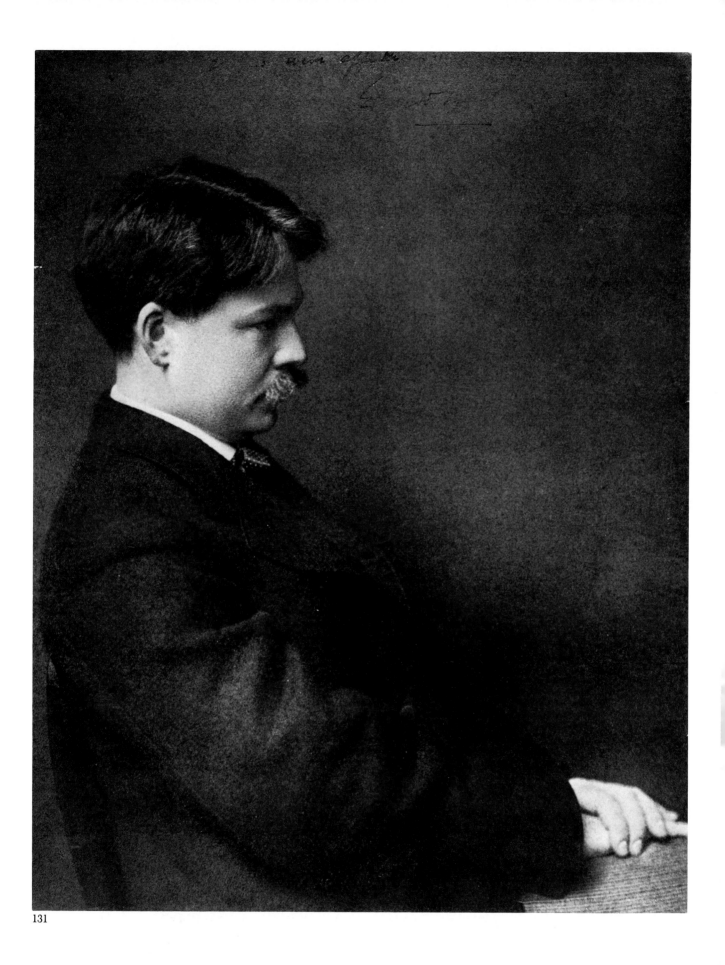

131

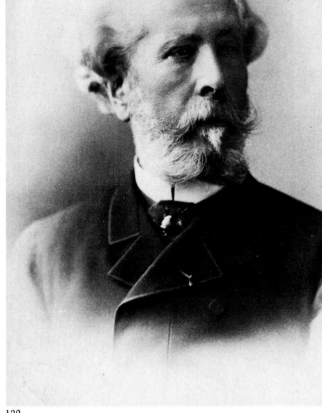

132

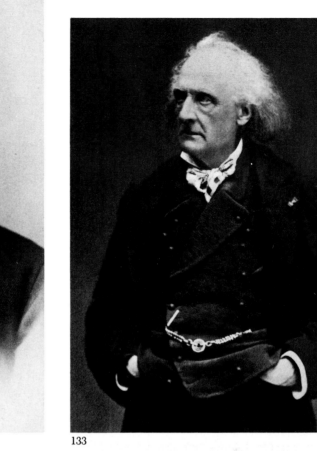

133

131. EDWARD MacDOWELL (1861–1908), American composer. Highly regarded today, his best-known works are the piano pieces "To A Wild Rose" and "To a Water Lily" from his suite *Woodland Sketches*. He composed other works for orchestra, piano and voice. 132. ÉDOUARD LALO (1823–1892), French composer of operas, songs and instrumental music, most notably the *Symphonie Espagnole* for violin and orchestra. 133. HENRY CHARLES LITOLFF (1818–1891), English composer (also pianist and publisher) mainly active on the continent. As a composer, published 115 works including the overture *Robespierre*, a programmatic piece. 134. LIZA LEHMANN (1862–1918), English composer most famous for her song cycle *In a Persian Garden*. She also composed operas and chamber music. (Photo: Deneulain, London.)

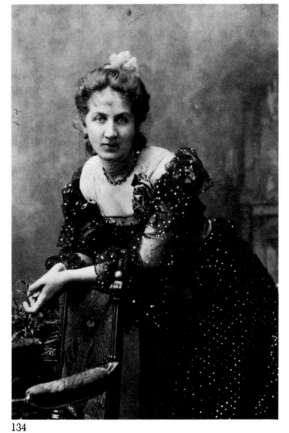

134

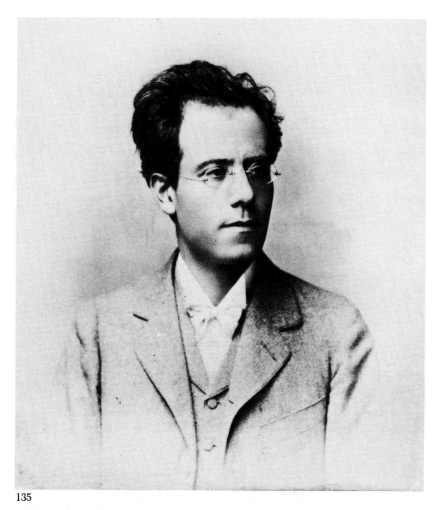

135

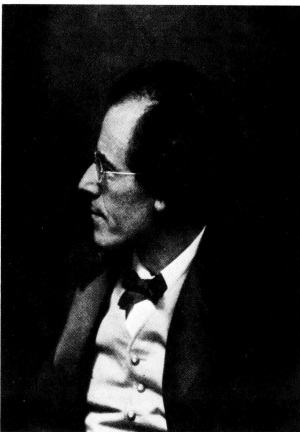

136

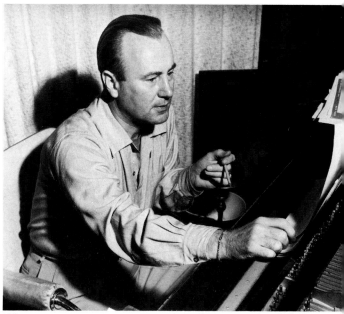

137

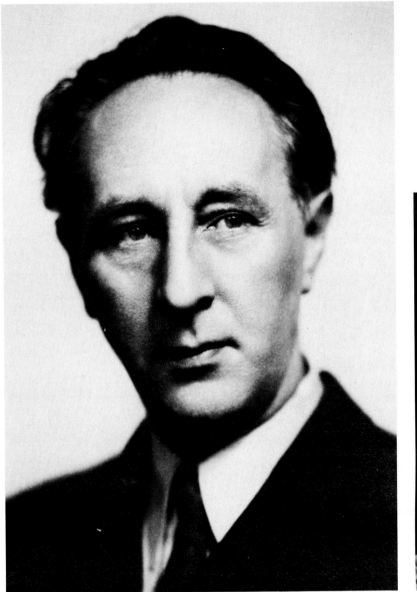

138

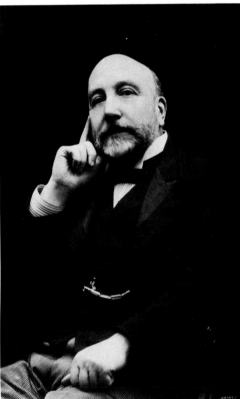

139

135 & 136. GUSTAV MAHLER (1860–1911), Bohemian-born Austrian composer. Considered a composer of the highest rank for his nine symphonies, his songs, etc., he was more celebrated in his lifetime as an opera conductor. 137. ALBERT HAY MALOTTE (1895–1964), American composer and organist. He composed the popular setting of "The Lord's Prayer" and several scores for Disney's *Silly Symphonies*. 138. BOHUSLAV MARTINU (1890–1959), Czech composer of operas, ballets, chamber and orchestral music. Lived in the United States from 1941 on. (Photo: Machacek Photo Studio, N.Y.) 139. (SIR) ALEXANDER MACKENZIE (1847–1935), Scottish composer of varied works including a popular opera, *The Rose of Sharon*.

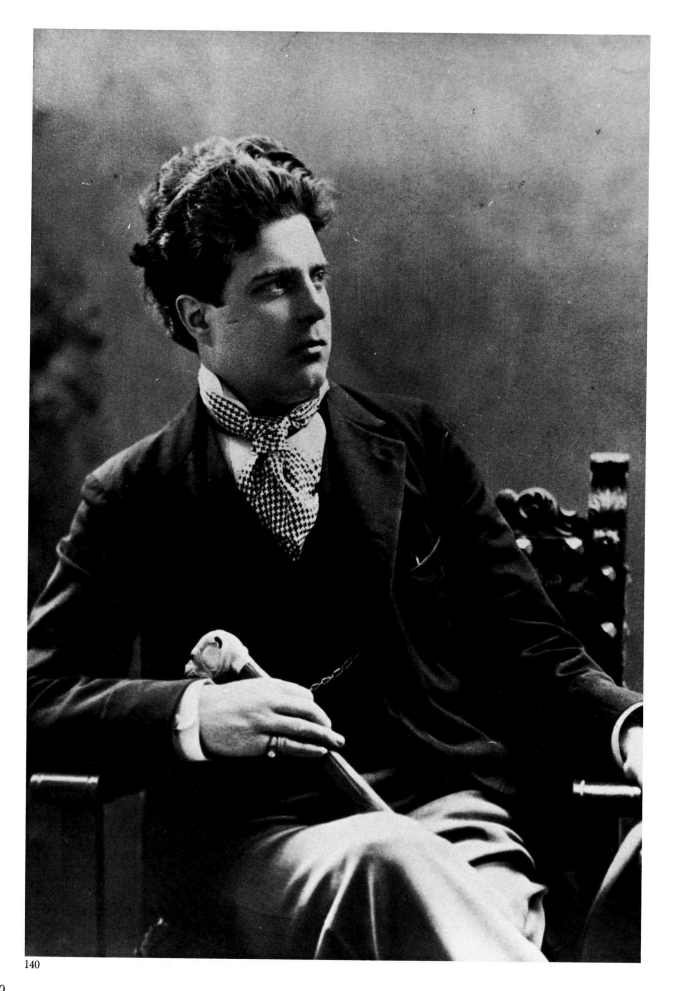

140

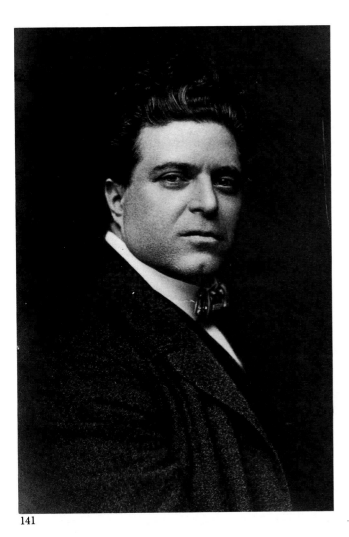

141

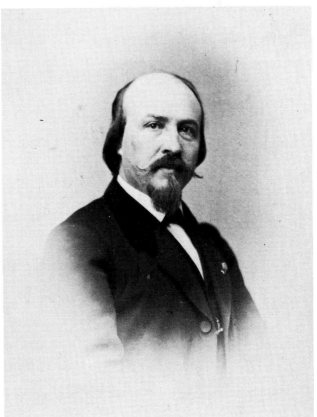

142

140 & 141. PIETRO MASCAGNI (1863–1945), Italian composer. Of his many operas, the only one to enjoy a success close to that of his popular *Cavalleria Rusticana* was *L'Amico Fritz*. See also No. 75. (Photo 141: Brogi.) 142. PETER MENNIN (born 1923), American composer of neo-Classical instrumental works. (Photo: Conway Studios, N.Y.; signed 1974.) 143. VICTOR MASSÉ (1822–1884), French composer of light operas, the most successful being *Les Noces de Jeannette*, produced in 1853. (Photo: E. Neurdein, Paris.)

143

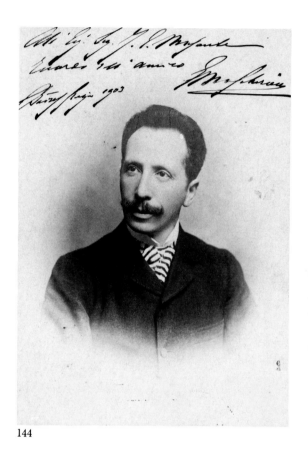

144

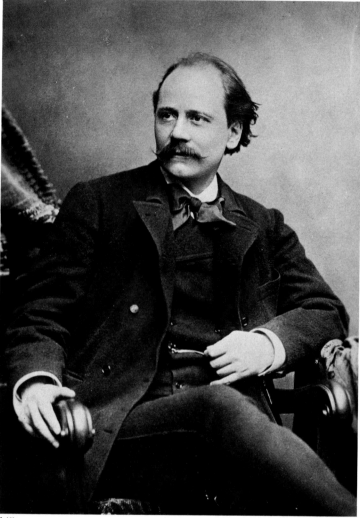

145

144. EDOARDO MASCHERONI (1852–1941), Italian composer and conductor. He composed two operas, *Lorenza* and *La Perugina*, but is best known as the conductor of the world premiere of Verdi's *Falstaff* at La Scala. (Photo: Witcomb, Buenos Aires; signed Buenos Aires, 1903.) 145. JULES MASSE-NET (1842–1912), French opera composer long known only for the three operas *Werther*, *Thaïs* and *Manon*, but becoming ever more popular.

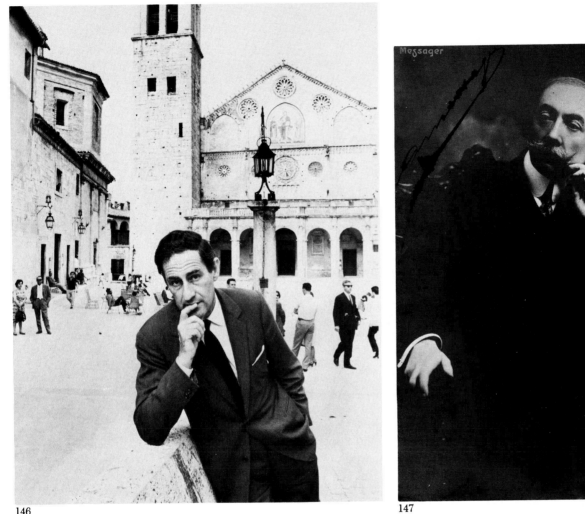

146

147

146. GIAN CARLO MENOTTI (born 1911), Italian-American opera composer. *Amahl and the Night Visitors* is one of his most successful works. He is the founder of the Spoleto Festival, held in Spoleto, Italy (scene of photo) and in Charleston, South Carolina. 147. ANDRÉ MESSAGER (1853–1929), French composer and conductor, student of Saint-Saëns. Messager composed many successful French operas and operettas including *Les p'tites Michu* (1897). He conducted the world premiere of Debussy's *Pelléas et Mélisande*, which was dedicated to him. (Photo: H. Manuel.)

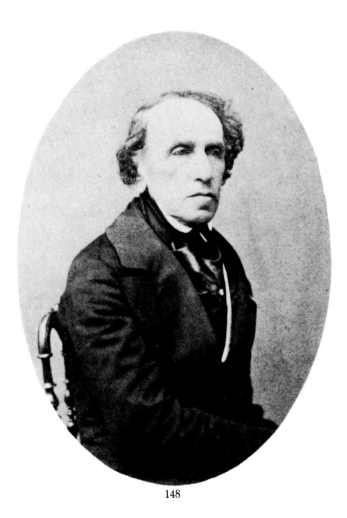

148

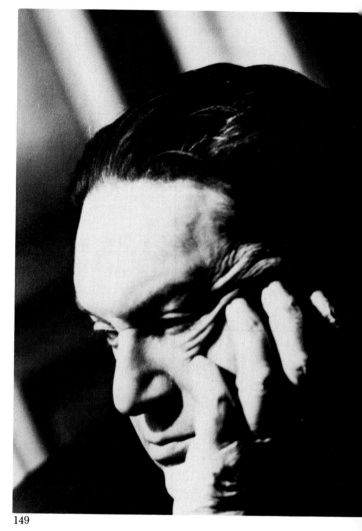

149

148. GIACOMO MEYERBEER (1791–1864), German-born composer of mostly French grand operas. Composed spectacularly successful operas—including *Robert le Diable*, *Les Huguenots* and *Le Prophète*—which fell into disfavor when the grand tradition of French singing declined. (Photo: Pierre Petit, Paris.) 149. DARIUS MILHAUD (1892–1974), French composer of all types of music including operas for children and the large-scale opera *Christophe Colomb*—his most successful—composed in 1930.

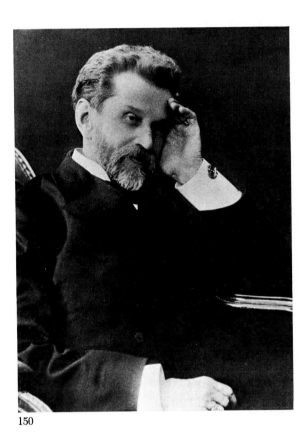

150

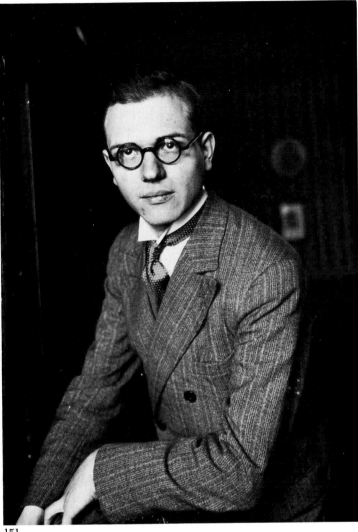

151

150. EDUARD NAPRAVNIK (1839–1916), Bohemian-born Russian composer and conductor. A successful composer of operas of which *Dubrovsky* is in the repertory in Russia. He conducted the world premiere of *Boris Godunov*. 151. OLIVIER MESSIAEN (born 1908), French composer, organizer of the group "La Jeune France." A very influential modernist composer.

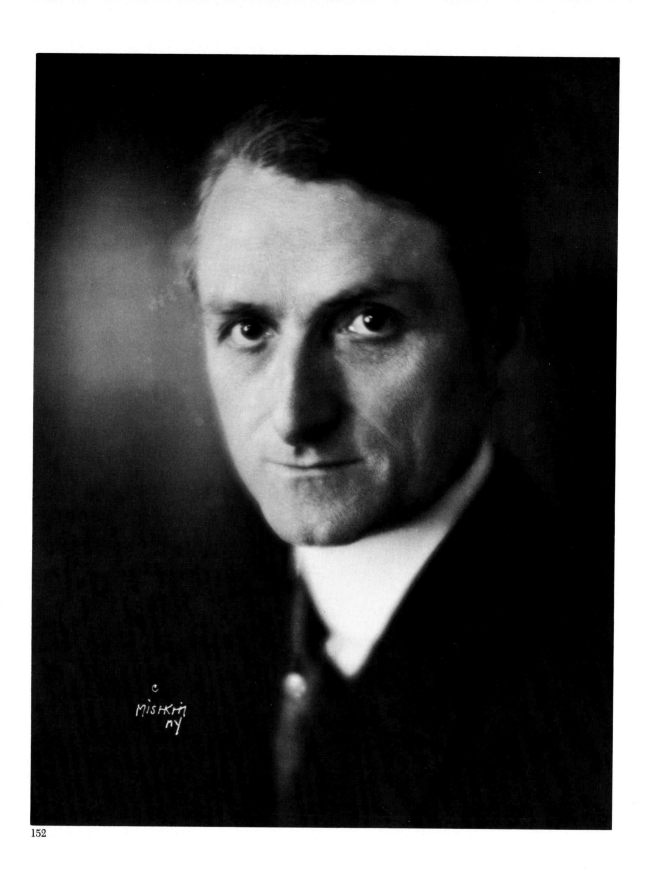

152

152. ITALO MONTEMEZZI (1875–1952), Italian opera composer remembered mainly for the once very popular *L'Amore dei Tre Re*. (Photo: Mishkin, N.Y.) 153. MODEST M(O)USSORGSKY (1839– 1881), Russian composer, member of "The Five." His *Boris Godunov* is the most famous Russian opera ever composed. His wrote many other operas, symphonic works and songs of distinction.

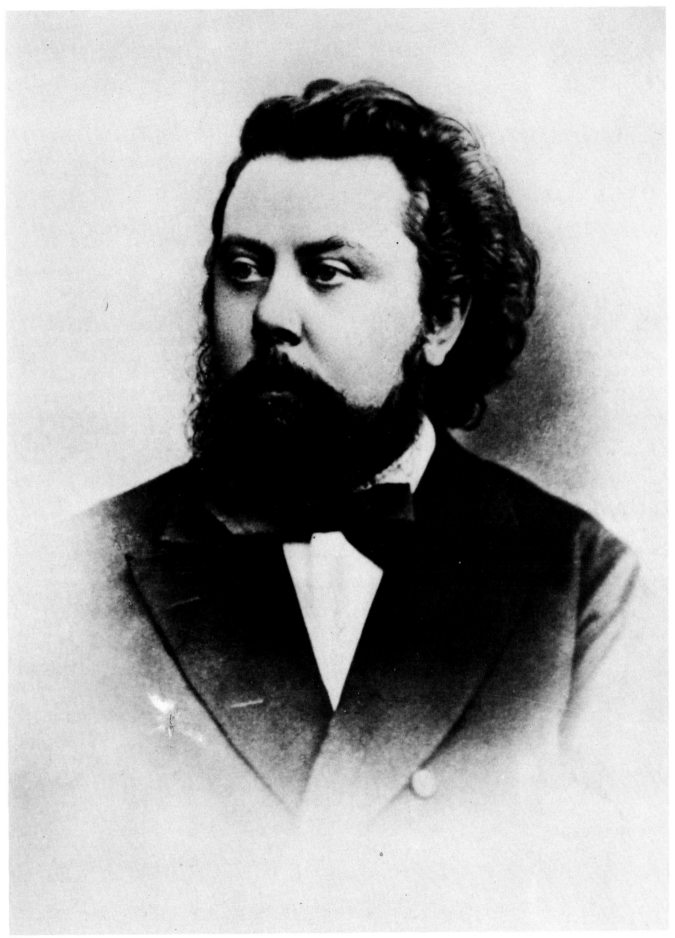

153

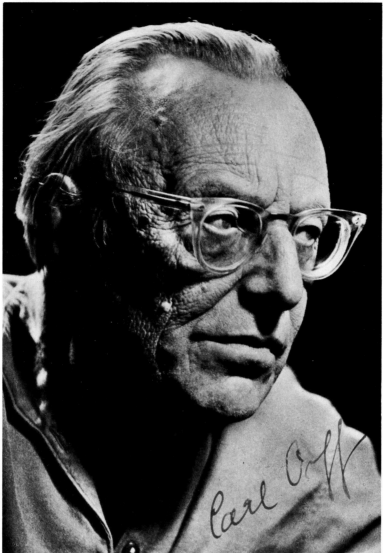

154

155

154. CARL ORFF (born 1895), German composer. His oratorio *Carmina Burana* is one of the most popular classical compositions of the 20th century. (Photo: W. Förster, Weilheim; signed 1973.) 155. OSKAR NEDBAL (1874–1930), Czech composer and conductor. Nedbal was a composer of many popular operettas, staged mainly in Vienna. 156. IGNACE JAN PADEREWSKI (1860–1941), Polish pianist and conductor. The most famous pianist of his time, Paderewski composed a successful opera, *Manru*, and many popular small-scale pieces including the famous "Minuet in G." 157. JACQUES OFFEN-BACH (1819–1880), German-born composer of French operettas. Offenbach's operettas were an institution in France in the 1860s and 1870s. Among his numerous hit operettas are *Orphée aux Enfers, La Belle Hélène, La Vie Parisienne* and *La Périchole.* (Photo: Mora, N.Y., 1876.)

156

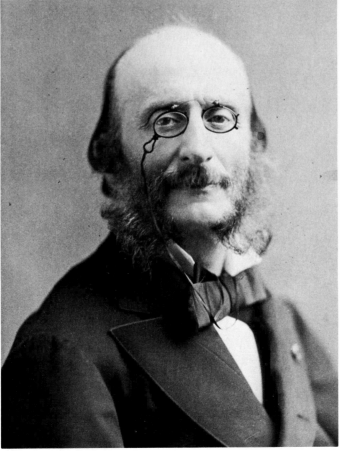

157

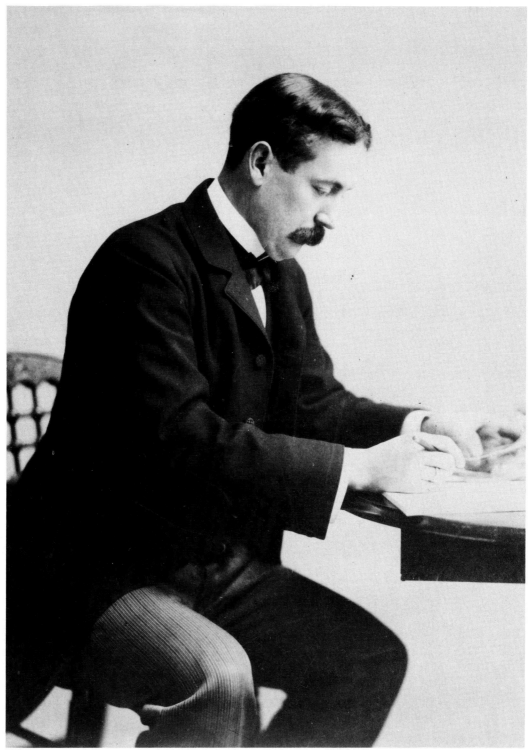

158

158. HORATIO PARKER (1863–1919), American composer of various works including *Mona*, an opera produced at the Metropolitan Opera in 1912. (Photo: G. C. Phelps, New Haven.) 159. (SIR) HUBERT H. PARRY (1848–1918), British composer. An active composer, especially providing English choral festivals with works that are now all but forgotten. 160. GEORGE PERLE (born 1915), American composer in a wide variety of genres, orchestral, chamber, choral, etc., using 12-tone concepts within a basically tonal format. Also writer of books on 12-tone composition. (Photo: Peter J. Harris.) 161. ILDEBRANDO PIZZETTI (1880–1968), Italian composer of operas and instrumental works. (Photo signed 1918.) 162. LORENZO PEROSI (1872–1956), Italian composer. A priest, he eschewed opera for sacred and orchestral music.

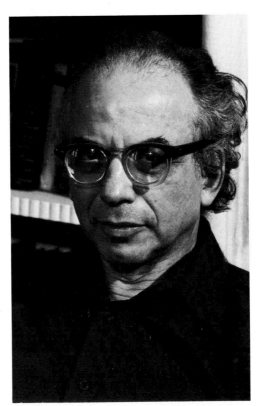

159

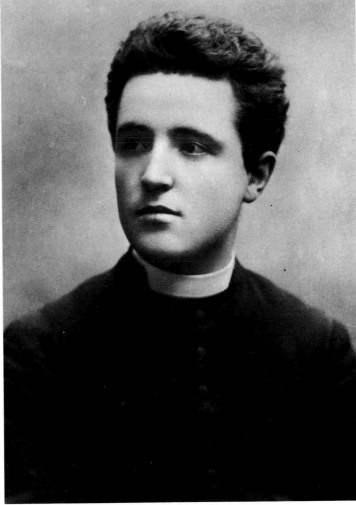

160

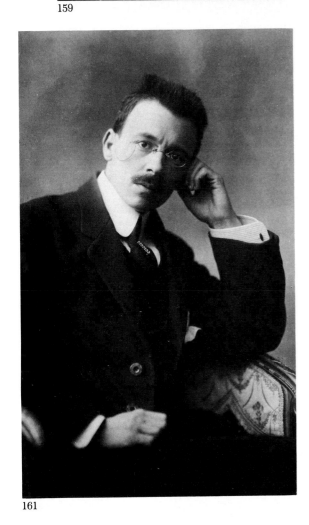

161

162

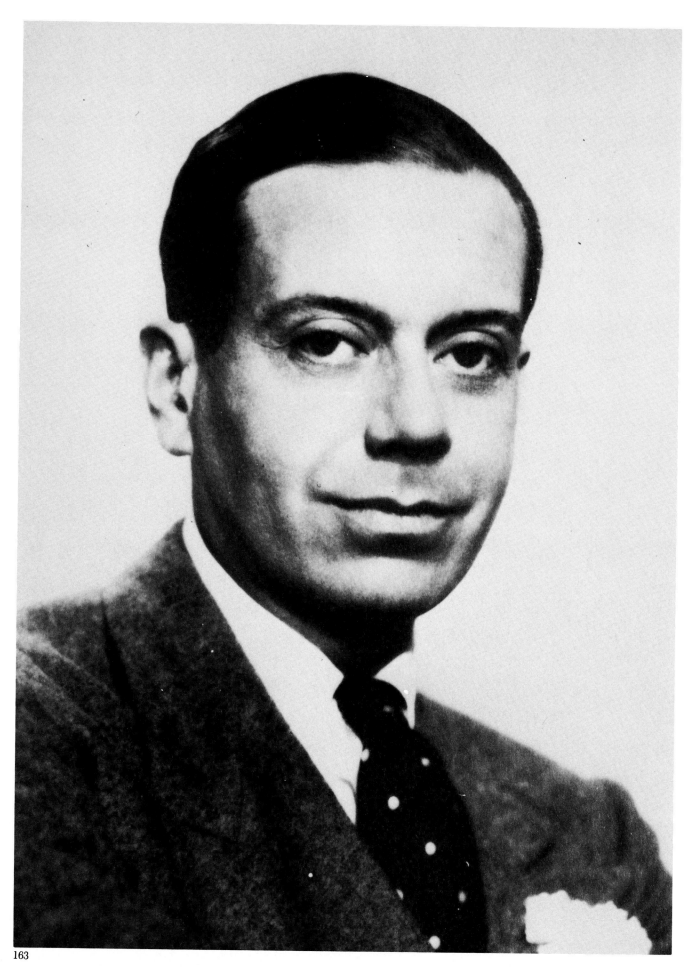

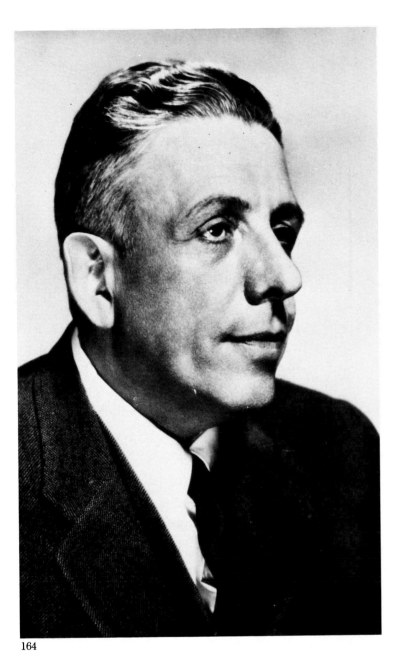

164

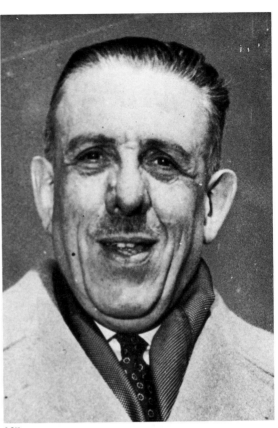

165

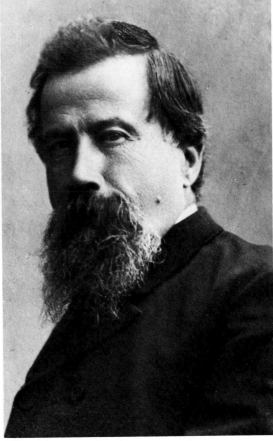

163. COLE PORTER (1893–1964), American composer of enormous popularity. Wrote many hit musicals with *Anything Goes* and *Kiss Me, Kate* as two of the standouts. 164 & 165. FRANCIS POULENC (1899–1963), successful French composer of many kinds of works, including the opera *Dialogues des Carmélites*. One of "Les Six." (Photo 164: Marcus Blechman, N.Y.) 166. AMILCARE PONCHIELLI (1834–1886), Italian opera composer remembered mainly as the teacher of Puccini and composer of *La Gioconda*.

166

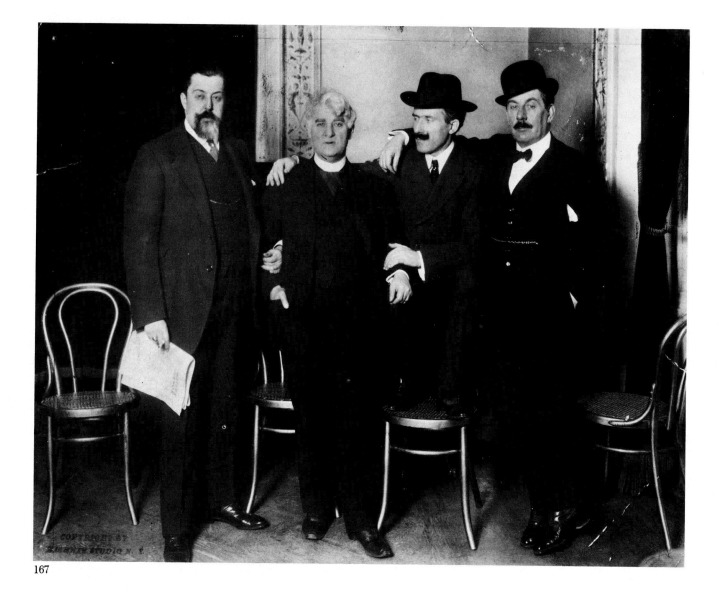

167

167 & 168. GIACOMO PUCCINI (1858–1924), Italian composer of *verismo* operas. Puccini was the most popular opera composer of his time and his masterpieces *La Bohème*, *Tosca* and *Madama Butterfly* are possibly the best-loved operas in the repertory. See also No. 75. In No. 167 (Photo: Mishkin, N.Y.), taken during the preparations for the Metropolitan Opera world premiere of *La Fanciulla del West*, Puccini is at the far right; the others, left to right, are: Giulio Gatti-Casazza, general director of the Met;

David Belasco, author of the play on which the opera was based, *The Girl of the Golden West*; and Arturo Toscanini, conductor of the premiere. 169. JOSEPH JOACHIM RAFF (1822–1882), Swiss-born German composer. Befriended by Mendelssohn and Liszt, Raff was a successful composer of Romantic operas, instrumental music and overtures which are being revived along with some of his piano concertos. (Photo: Mondel & Jacob, Wiesbaden, 1878.)

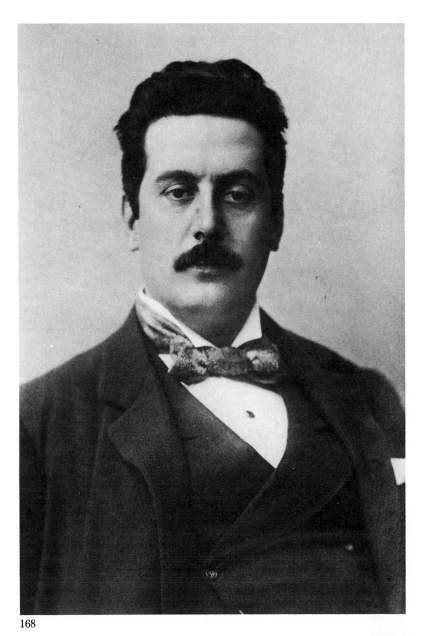

168

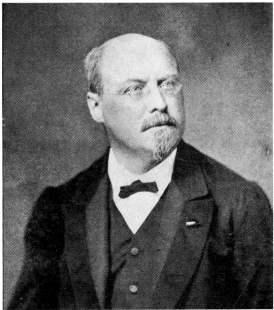

169

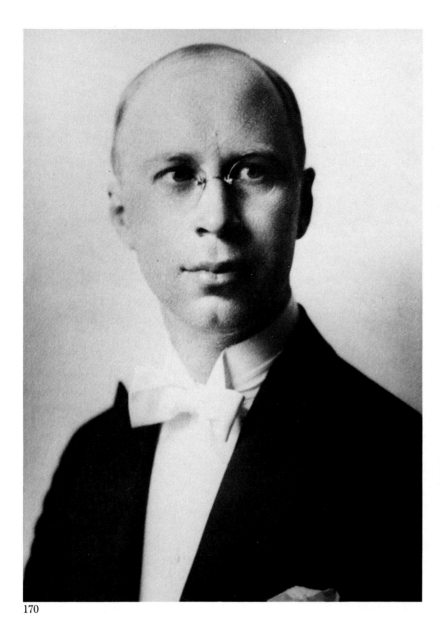

170

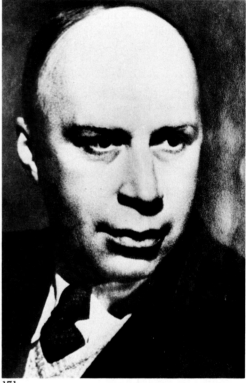

171

170 & 171. SERGE PROKOFIEV (1891–1953), Russian composer. Composed many classics of the 20th-century repertory including *Peter and the Wolf*, the ballet *Romeo and Juliet* and the opera *Love for Three Oranges*.

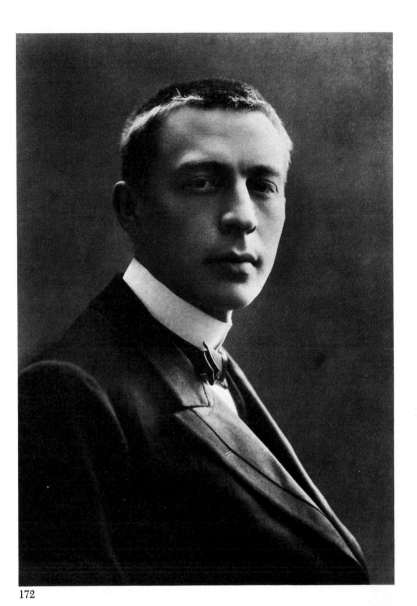

172

172 & 173. SERGEI RACHMANINOFF (1873–1943),
Russian composer and pianist. As a composer, he had
great success with his opera *Aleko*, four piano concer-
tos and many other works. He was one of the greatest
pianists of his time.

173

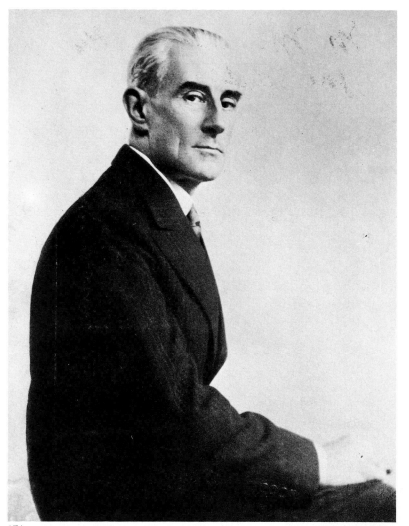

174

174. MAURICE RAVEL (1875–1937), French composer of many works including important piano suites and two notable operas *(L'Enfant et les Sortilèges* and *L'Heure Espagnole)*. His most popular composition is *Boléro*. 175. CARL REINECKE (1824–1910), German composer. Wrote many Romantic pieces including a harp concerto that is still performed. (Photo: Georg Brokesch, Leipzig.) 176. OTTORINO RESPIGHI (1879–1936), Italian composer, student of Rimsky-Korsakov. Although he composed operas and many other works, he is chiefly remembered for his symphonic poem *Pines of Rome.* (Photo: Brown Brothers.) 177. MAX REGER (1873–1916), German composer. Reger composed a large amount of music in his short lifetime, including many excellent works for organ. (Photo: Gebr. Lützel.)

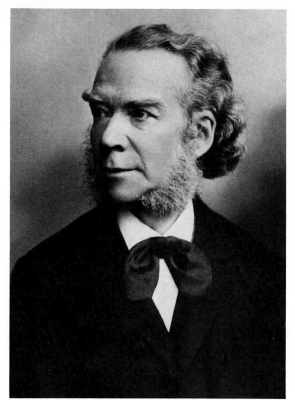

175

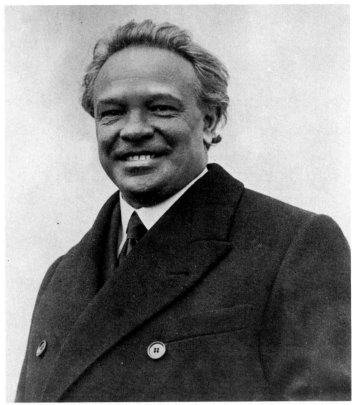

176

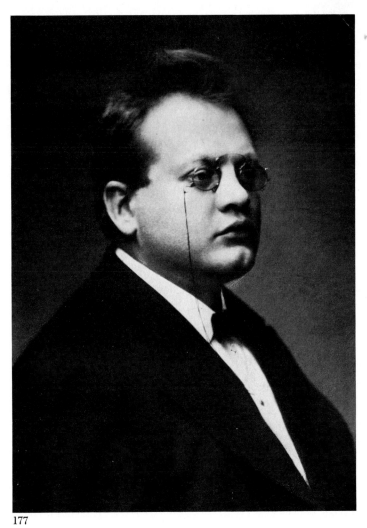

177

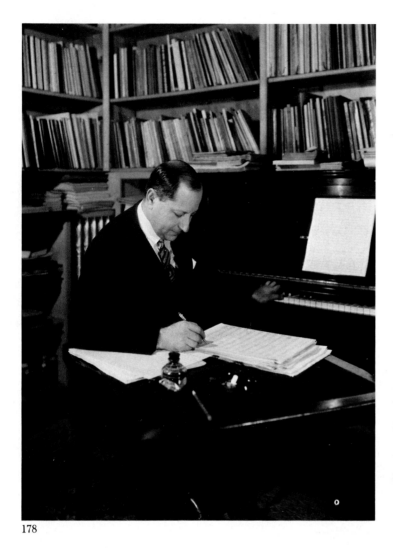

178

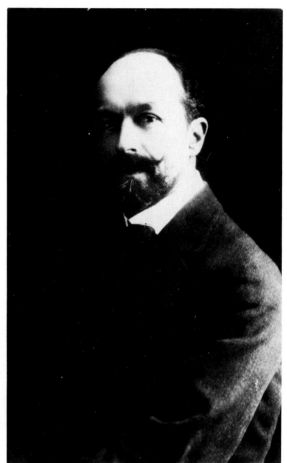

179

178. SIGMUND ROMBERG (1887–1951), Hungarian-born composer of operettas for the American musical stage including *The Student Prince* and *The Desert Song*. (Photo: Underwood & Underwood, ca. 1925.) 179. ALBERT ROUSSEL (1869–1937), French composer and teacher of Satie. Roussel was a prolific composer of operas, ballets, symphonic and chamber music. (Photo: Chéri Rousseau.) 180. NIKOLAI RIMSKY-KORSAKOV (1844–1908), Russian composer and teacher; member of "The Five." A very active composer of operas, including *Sadko* and *The Snow Maiden*, he also wrote the famous orchestral work *Scheherazade*.

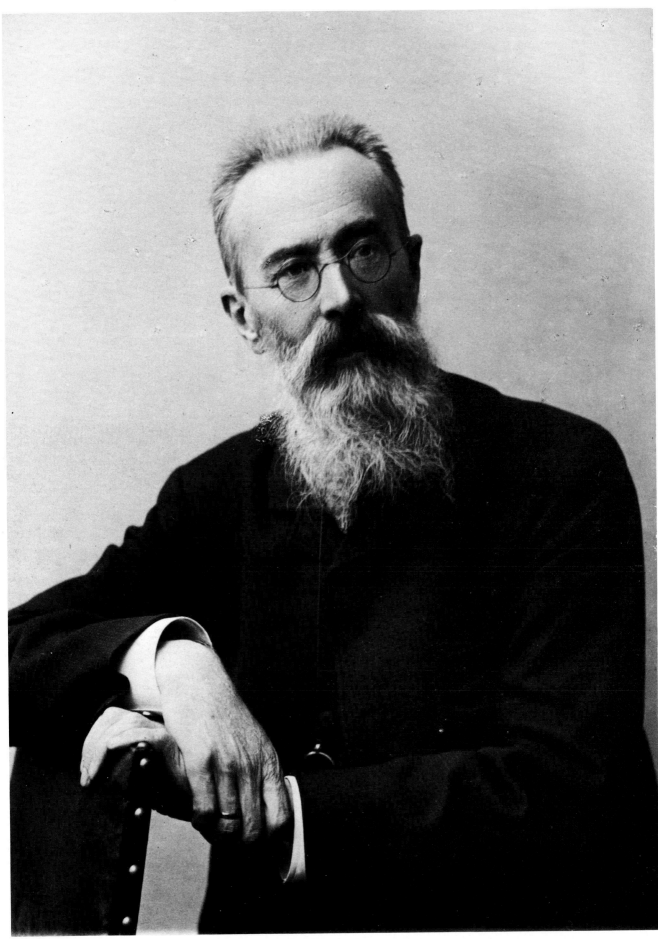

To Pam green with all best wishes Ned Rorem 1968

181

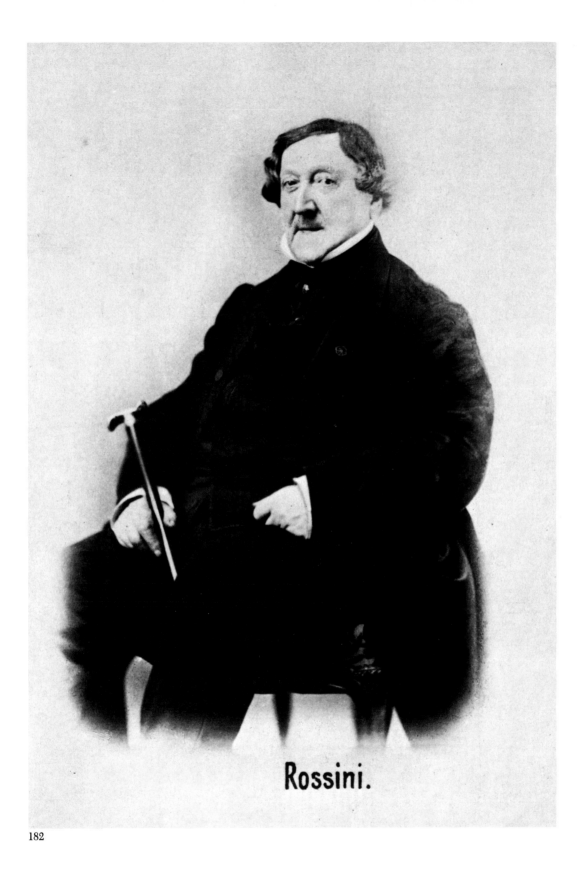

Rossini.

182

181. NED ROREM (born 1923), American composer. One of the most successful modernists. (Photo signed 1968.) 182. GIOACCHINO ROSSINI (1792–1868), Italian opera composer. His *Barber of* *Seville* is one of the classics. Others include *William Tell* (the first French grand opera), *La Cenerentola*, *La Gazza Ladra*, etc., still famous at least for their overtures, which are concert staples.

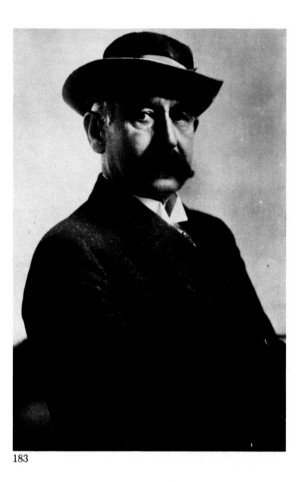

183

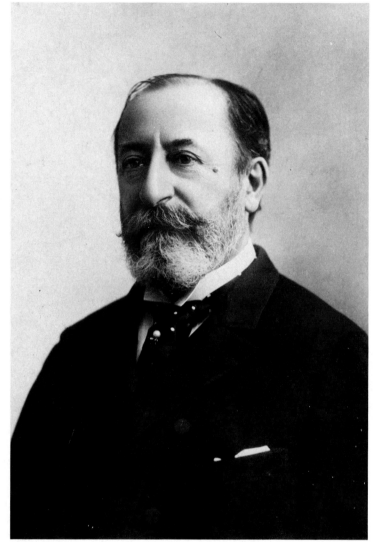

184

183. XAVER SCHARWENKA (1850–1924), German pianist and composer. Scharwenka was best known as a pianist, but he wrote an opera, *Mataswintha* (produced at the Met in 1907), four piano concertos that are revived today, and many other works. (Photo: H. Lassmann, Munich.) 184. CAMILLE SAINT-SAËNS (1835–1921), French composer and organ virtuoso. Saint-Saëns composed a variety of successful works including the opera *Samson and Delilah*, the orchestral *Carnival of the Animals* and several symphonies, concertos and solo instrumental pieces. (Photo: Reutlinger, Paris.) 185. ANTON RUBINSTEIN (1829–1894), Russian composer and pianist. One of the great pianists of his time, he was also a successful composer of operas (including *The Demon*) and instrumental music, notably his piano concertos and his *Ocean Symphony*, which gained him worldwide fame. 186. GYÖRGY SÁNDOR (born 1912), Hungarian composer and pianist, student of Bartók and Kodály. He is noted for his transcriptions of orchestral works for piano. See also No. 14. 187. OTHMAR SCHOECK (1886–1957), Swiss composer and conductor. He composed many works, but is best known for his songs.

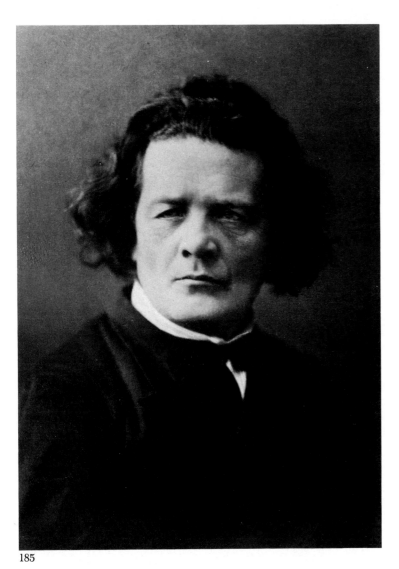

185

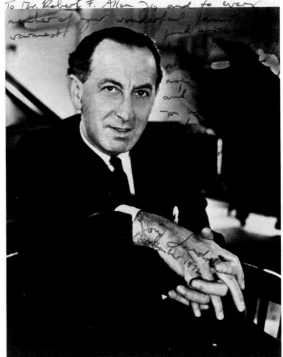

186

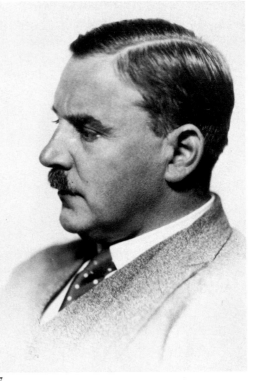

187

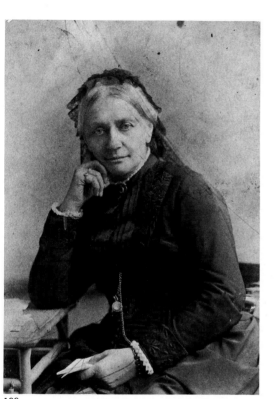

188

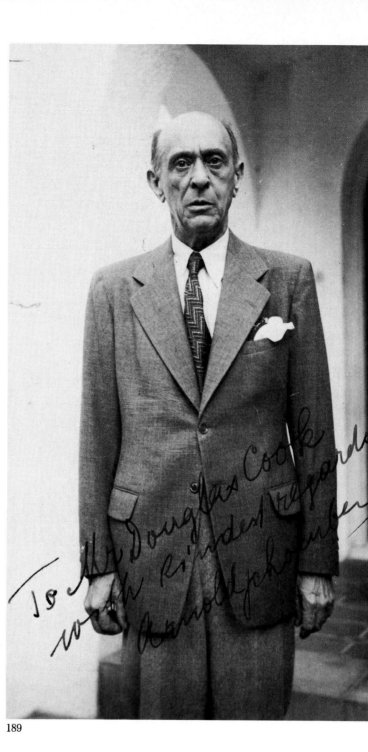

189

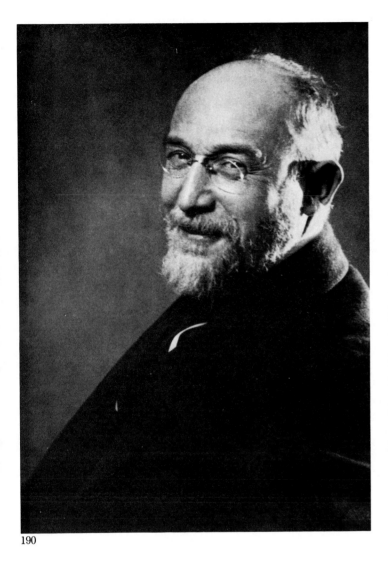

190

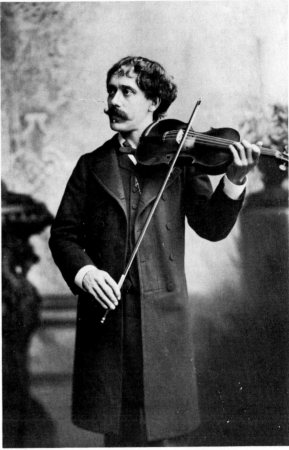

191

188. CLARA SCHUMANN (née Wieck; 1819–1896), German pianist; wife of Robert Schumann, who used some of her melodies for his compositions. She composed a fine piano concerto and some solo piano music and songs. She was one of the outstanding pianists of her time. (Photo: Elliott & Fry, London.) 189. ARNOLD SCHOENBERG (1874–1951), Austrian composer who abandoned the tonal system for his new 12-tone music. Among his more accessible works are the early *Gurre-Lieder*, composed over a number of years. He was active in the United States from 1933 on. 190. ERIK SATIE (1866–1925), French composer. A very influential composer whose witty, intellectual music has become more popular recently. His most famous work was probably the ballet *Parade*, composed in 1917. 191. PABLO DE SARASATE (1844–1908), Spanish violin virtuoso who composed many effective pieces, mainly for violin.

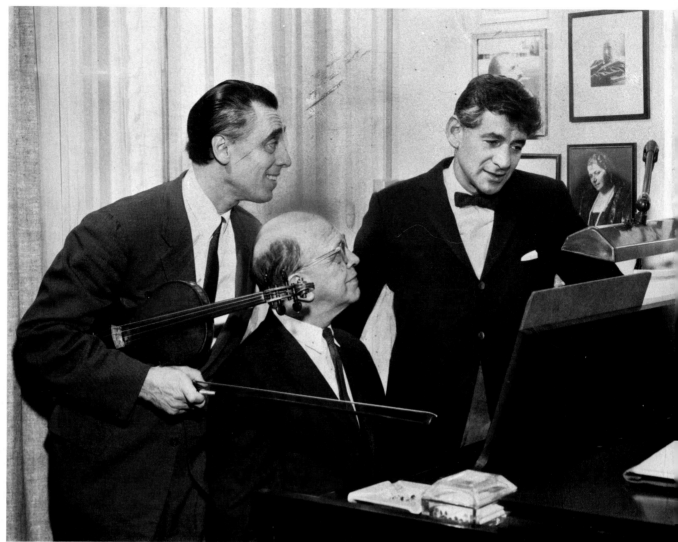

192

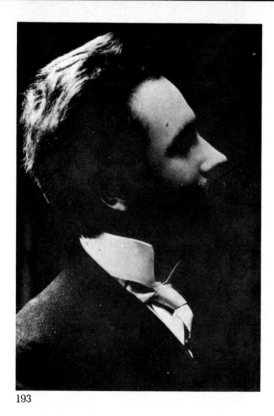

193

192. ROGER SESSIONS (born 1896), American composer, student of Ernest Bloch (see No. 27). His Symphony in E Minor was premiered by the Boston Symphony under Koussevitzky in 1927. In the photo he seated at the pianio between violinist Tossy Spivakovsky and conductor Leonard Bernstein (see also No. 20). (Photo: Bakalar-Cosmo, N.Y.) 193. ALEXANDER SCRIABIN (1872–1915), Russian composer. Scriabin's music is highly regarded for its harmonic innovations. He wrote both important piano music and symphonic works. (Photo: Hans Dursthoff, Berlin, 1908.) 194. GUNTHER SCHULLER (born 1925), American composer of various works, many of which reflect his attempt to marry classical music with the jazz idiom.

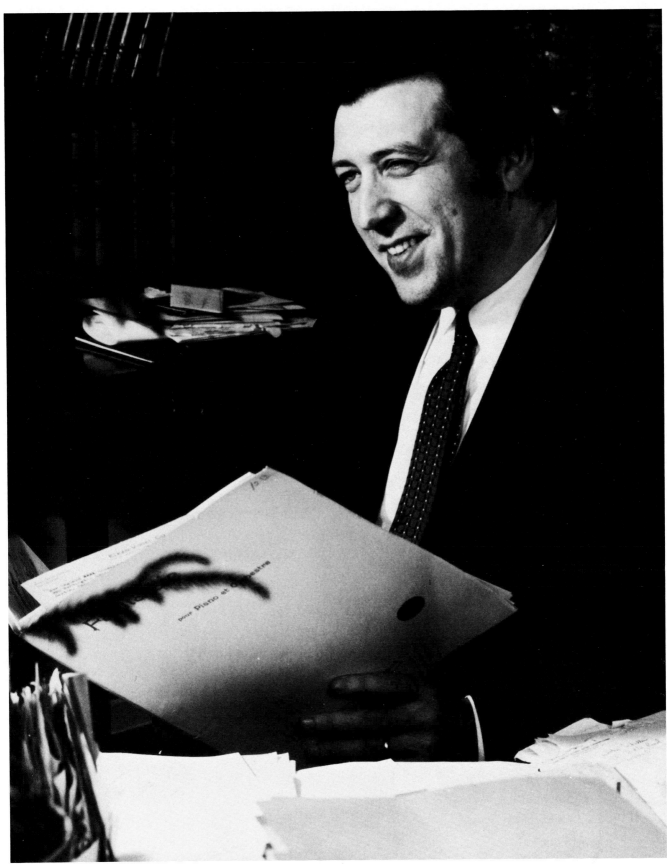

194

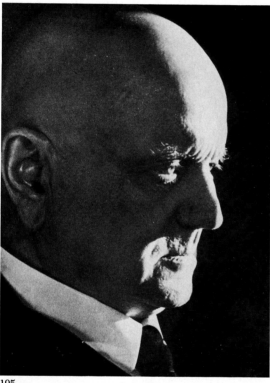

195

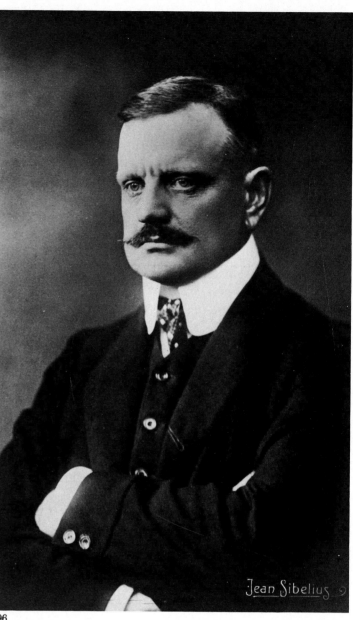

196

195 & 196. JEAN SIBELIUS (1865–1957), Finnish neo-Romantic composer of very successful songs, symphonies and numerous other works. 197. DMITRI SHOSTAKOVICH (1906–1975), Russian composer especially noted for his 15 symphonies. He has been called the last major classical composer. 198. CHRISTIAN SINDING (1856–1941), Norwegian composer of many works in a Romantic style. He is most famous for "Rustles of Spring."

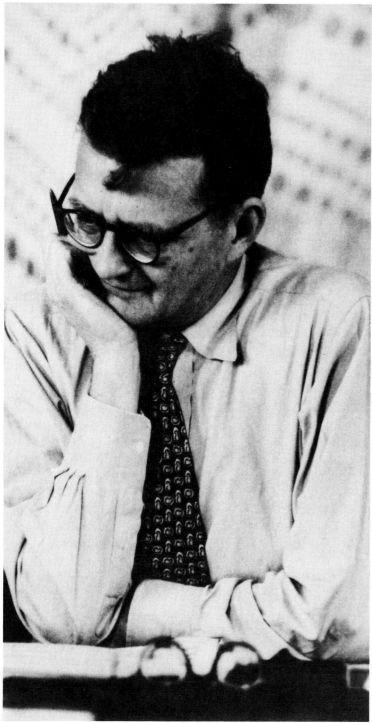

197

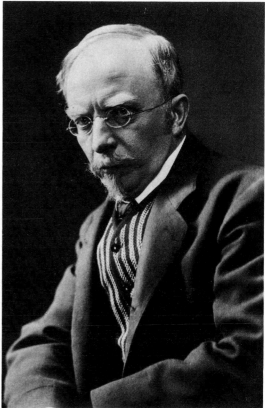

198

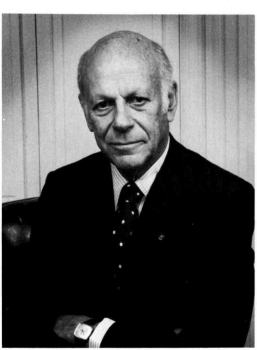

199

200

199. WILLIAM SCHUMAN (1910–1981), American composer of ballets, symphonies, choral works and a variety of other pieces. He became president of the Juilliard School of Music in 1945. (Photo: Carl Mydans.) 200. JOHN PHILIP SOUSA (1854–1932), American composer. Dubbed "the March King," Sousa composed many still famous marches, including *The Stars and Stripes Forever,* and several comic operas. 201. BEDŘICH SMETANA (1824–1884), Bohemian composer, pianist and conductor. World famous for his opera *The Bartered Bride* and his tone poem *The Moldau,* Smetana wrote many other impressive works. 202. (SIR) JOHN STAINER (1840–1901), English composer and organist. His compositions were chiefly sacred works. 203. (SIR) CHARLES STANFORD (1852–1924), Irish composer and teacher, student of Reinecke. He composed many works in the Romantic style using Irish and English folk material. (Photo: Bacon, Leeds.)

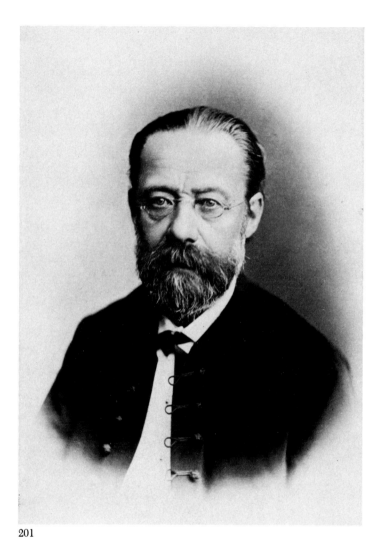

201

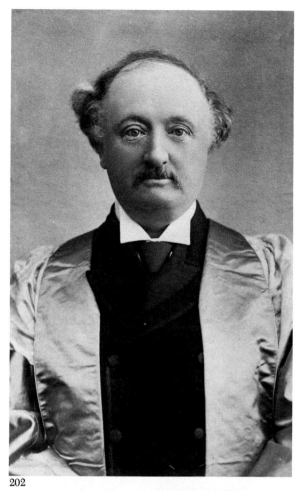

202

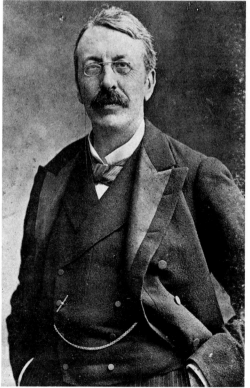

203

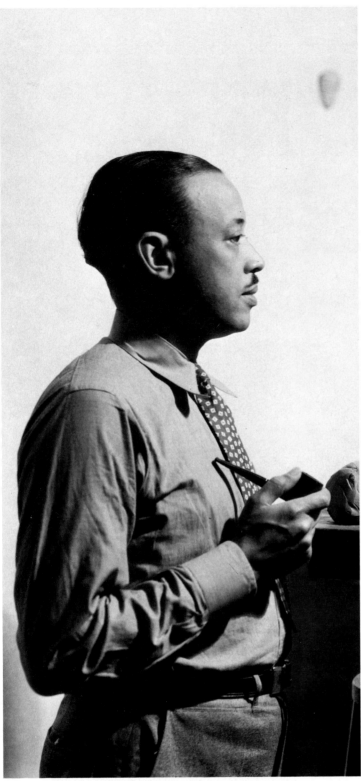

204

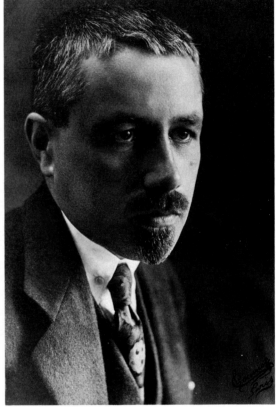

205

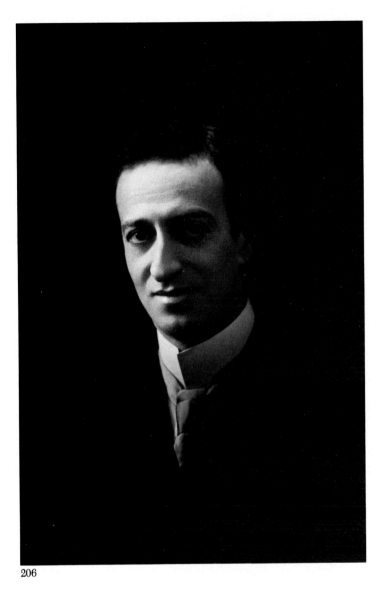

206

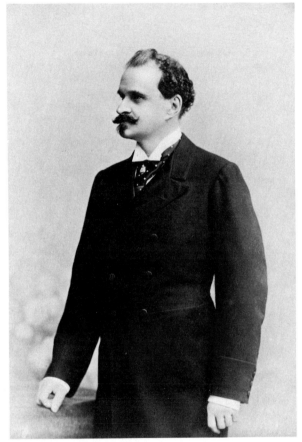

207

204. WILLIAM GRANT STILL (born 1895), American composer, student of Chadwick. Among his many works are the *Afro-American Symphony* and the opera *Troubled Island*. (Photo: Floyd Faxon, Los Angeles, 1939.) 205. MAXIMILIAN STEINBERG (1883–1946), Russian composer, student of Glazunov and Rimsky-Korsakov, teacher of Shostakovich. He composed a variety of works including a ballet, *Metamorphoses*, for Diaghilev, performed in 1914. (Photo: Choumoff, Paris; signed Paris, 1927.)

207. OSCAR STRAUS (1870–1954), Austrian composer of operettas, the most successful of which were *A Waltz Dream* and *The Chocolate Soldier*. (Photo: Dover Street Studios, London.) 207. EDUARD STRAUSS (1835–1916), Austrian composer and conductor. No match, as a composer, for his older brothers Johann (Jr.) and Josef, Eduard made his mark chiefly as conductor of the orchestra founded by their father (Johann, Sr.).

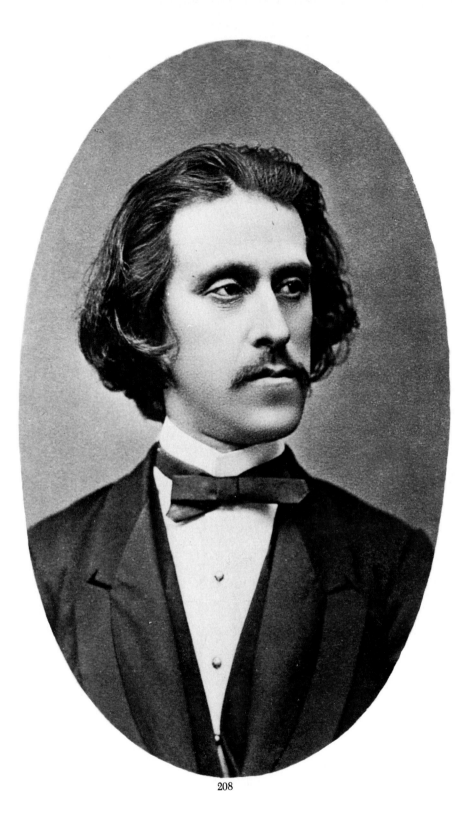

208

208. JOSEF STRAUSS (1827–1870), Austrian composer of waltzes which, despite their great merit, are not as popular as those of his brother Johann, Jr. A theme from Josef's set of waltzes *Dynamiden* was reused by Richard Strauss in *Der Rosenkavalier*.

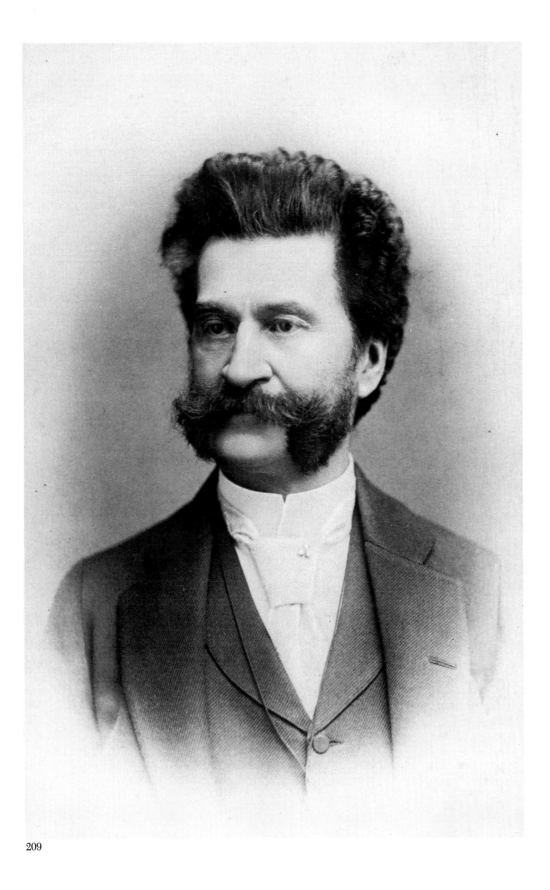

209

209. JOHANN STRAUSS, JR. (1825–1899), Austrian composer. Dubbed "the Waltz King," Strauss was an enormously popular composer of dance music and of operettas, of which the most famous is *Die Fledermaus*.

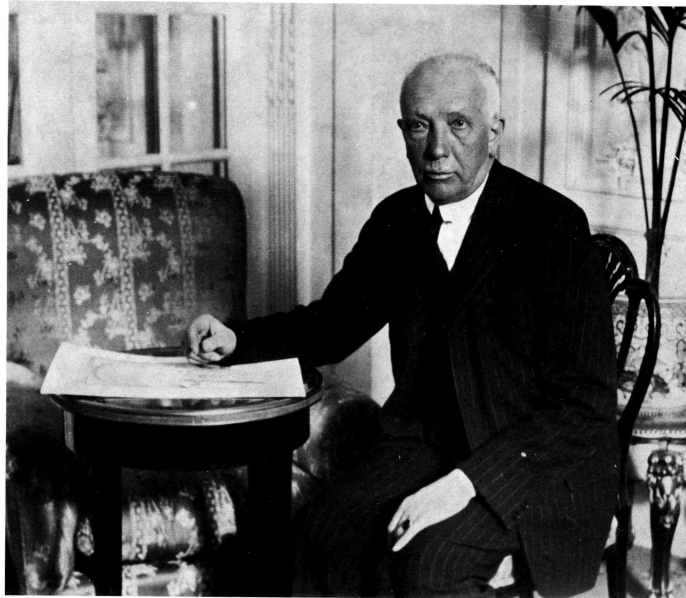

210

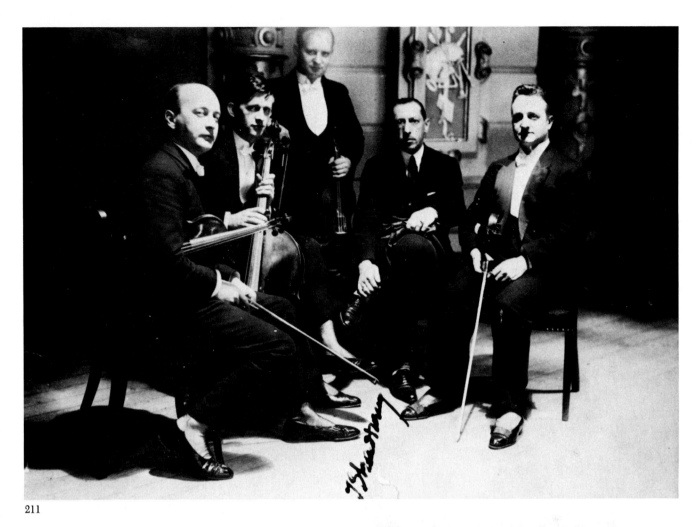

211

210. RICHARD STRAUSS (1864–1949), German composer. Strauss is as famous for his orchestral works such as *Don Juan, Till Eulenspiegels lustige Streiche* and *Ein Heldenleben* as for his operas *Salome, Elektra, Der Rosenkavalier* and others. He also wrote many notable songs, and is regarded by many as probably the greatest composer of the 20th century. 211. IGOR STRAVINSKY (1882–1971), Russian composer. Especially celebrated for his daring ballets of the early 1910s, *Firebird, Petrouchka* and *The Rite of Spring,* he composed a great variety of innovative works that made him one of the chief trend setters of the 20th century. In this photo, Stravinsky (holding hat and gloves) is seen with the Hindemith Quartet; Hindemith (see No. 109) is standing. See also Frontispiece. 212. JOSEF SUK (1874–1935), Czech composer and violinist; student of Dvořák, whose daughter he married. He wrote many works in a Romantic vein, including the symphony *Asrael* in memory of his late wife and her father.

212

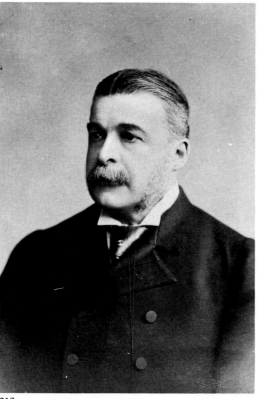

213

214

213 & 214. (SIR) ARTHUR SULLIVAN (1842–1900), English composer. Working with the librettos of W. S. Gilbert, he composed many classic light operas including *The Mikado, H.M.S. Pinafore* and *The Pirates of Penzance*. He also wrote the grand opera *Ivanhoe*, oratorios and such songs as "Onward, Christian Soldiers," and "The Lost Chord." (Photo 213: Chancellor & Son, Dublin. Photo 214: H. J. Whitlock, Birmingham.) 215. FRANZ VON SUPPÉ (1819–1895), Austrian composer of operettas and theater music. Best remembered for his overtures to *Poet and Peasant* and *Light Cavalry* and for such operettas as *Boccaccio* and *Die schöne Galatea*. 216. JOHANN SVENDSEN (1840–1911), Norwegian violinist and composer, most famous for his *Four Norwegian Rhapsodies* for orchestra. 217. DEEMS TAYLOR (1885–1966), American composer, once well known for such works as the two operas produced at the Metropolitan Opera, *The King's Henchman* in 1926 and *Peter Ibbetson* in 1931. In the (1937) photo, Taylor is at the right; at the piano is conductor André Kostelanetz; behind him is baritone Lawrence Tibbett.

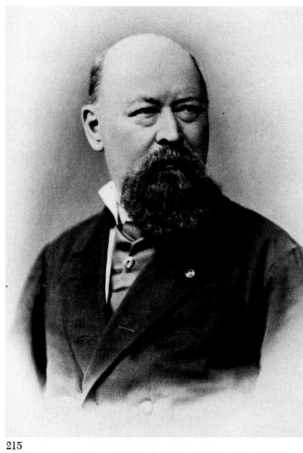

215

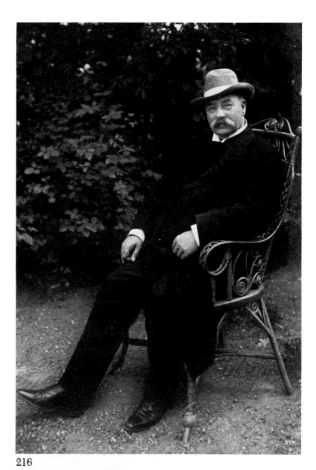

216

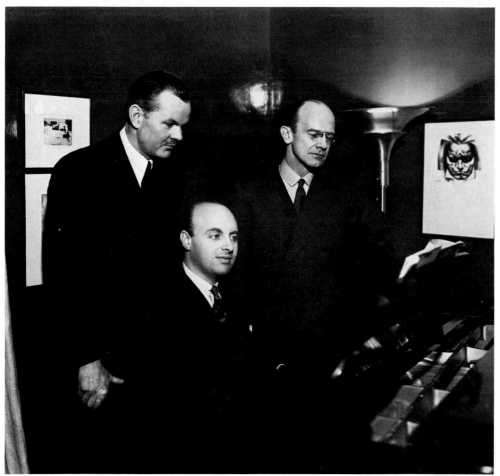

217

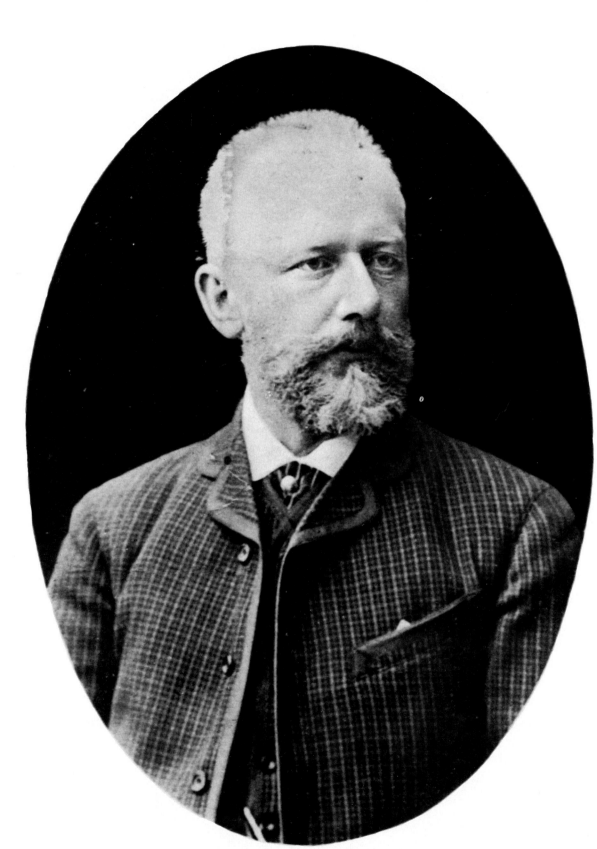

218

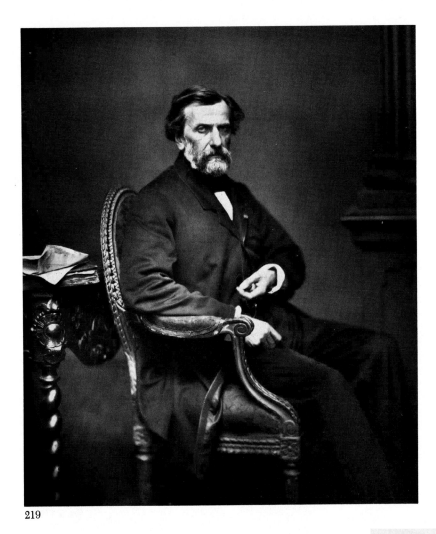

219

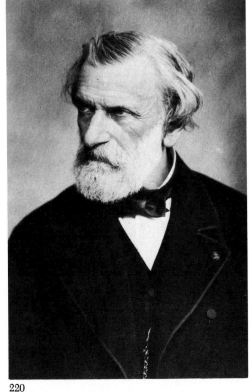

220

218 & 221. PETER ILYITCH TCHAIKOVSKY (1840–1893), Russian composer. One of the giant composers of the 19th century for such works as his ballets *The Nutcracker*, *Swan Lake* and *Sleeping Beauty*; several outstanding symphonies and operas; and the *1812 Overture*. 219 & 220. AMBROISE THOMAS (1811–1896), French composer. Of his numerous operas, all are now out of the repertory except for *Mignon* and occasionally *Hamlet*. (Photo 219: Adam-Salomon, for *Galerie Contemporaine*.)

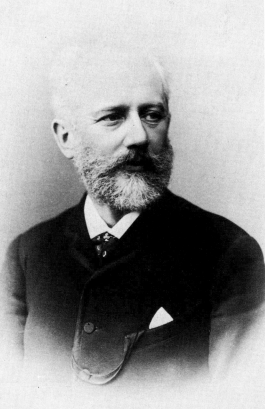

221

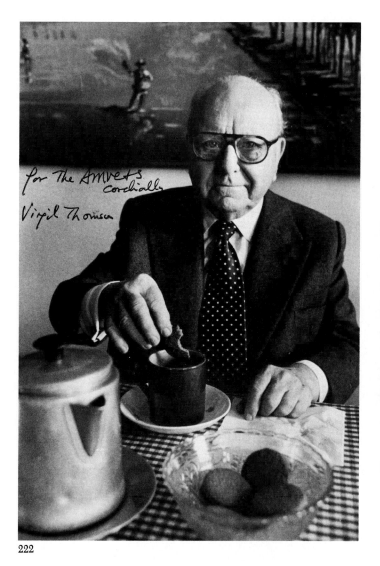

222

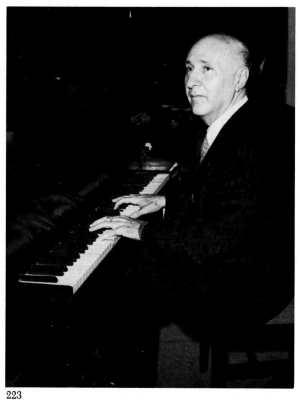

223

222. VIRGIL THOMSON (born 1896), American composer, student of Nadia Boulanger. Thomson has tried most forms of composition, achieving his greatest success with an opera set to a libretto by Gertrude Stein, *Four Saints in Three Acts*, and providing memorable scores for important film documentaries. He was also an outstanding music critic for the New York *Herald Tribune* from 1940 to 1954. (Photo: Thomas Victor.) 223. DIMITRI TIOMKIN (1894–1979), Russian-born composer active mainly in Hollywood. He won Academy Awards for his music for the films *High Noon* and *The Old Man and the Sea*, and received numerous other nominations. 224. (SIR) PAOLO TOSTI (1846–1916), Italian song composer. Singing master to the queen of Italy, later to the British royal family, he composed many pleasant songs including "Goodbye" and "Aprile." In the photo he is in the center, standing between baritone Antonio Scotti and tenor Enrico Caruso. 225. (SIR) MICHAEL TIPPETT (born 1905), British composer of various works including the operas *The Midsummer Marriage* and *King Priam*.

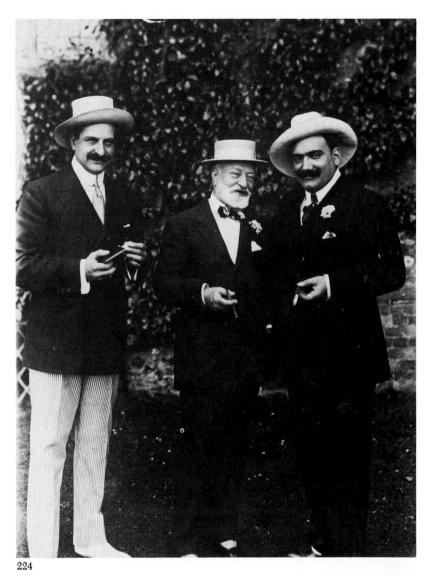

224

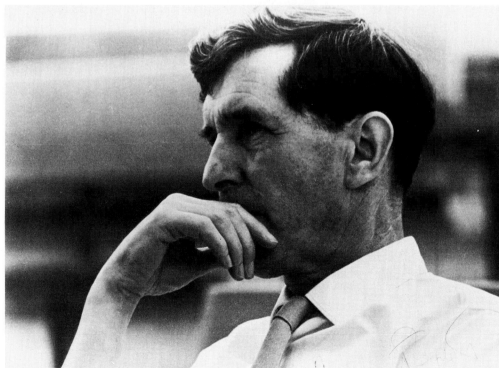

225

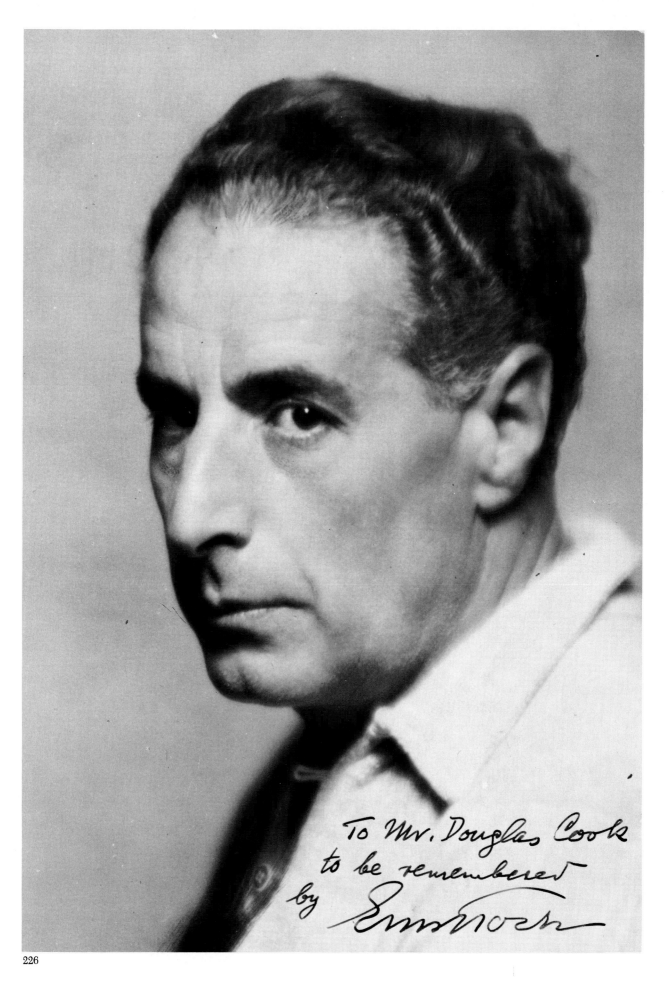

To Mr. Douglas Cook
to be remembered
by Ernst Toch

226

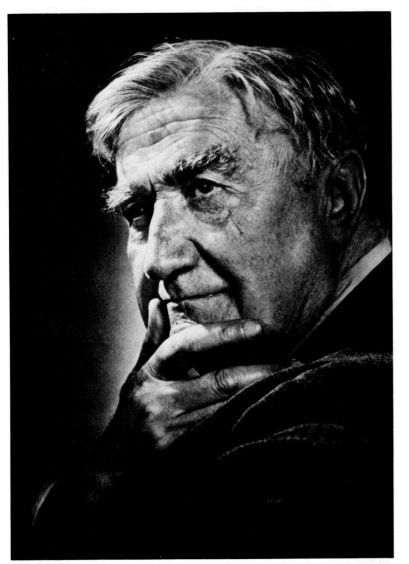

227

226 & 228. ERNST TOCH (1887–1964), Austrian composer long active in the United States. Composed operas, chamber music, symphonies and film music. (Photo 226: Buxbaum, Los Angeles.) 227. RALPH VAUGHAN WILLIAMS (1872–1958), British composer. Vaughan Williams made famous arrangements of English folk songs and composed many original works including nine symphonies, concertos, choral pieces and operas, notably *Hugh the Drover*.

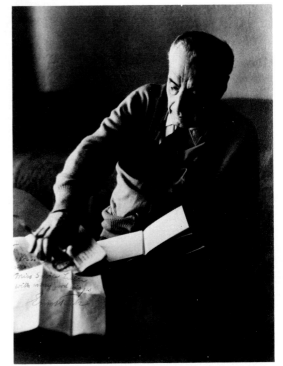

228

117

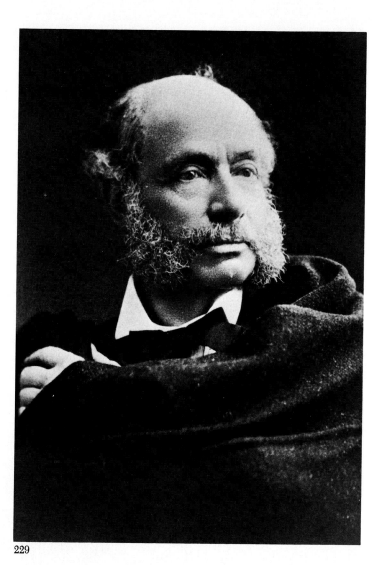

229

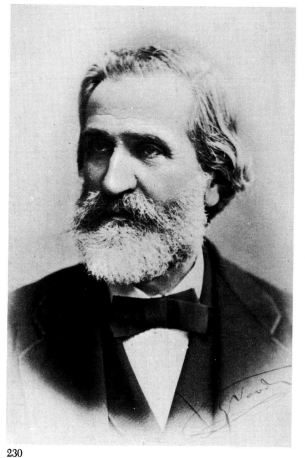

230

229. HENRI VIEUXTEMPS (1820–1881), Belgian violin virtuoso and composer, especially of seven violin concertos. 230 & 231. GIUSEPPE VERDI (1813–1901), Italian composer. Verdi is regarded as the grand master of 19th-century Italian opera and choral music. His classics include *Rigoletto*, *La Traviata*, *Aïda*, *Otello*, *Il Trovatore* and the *Requiem*. (Photo 231: Ch. Reutlinger, Paris.)

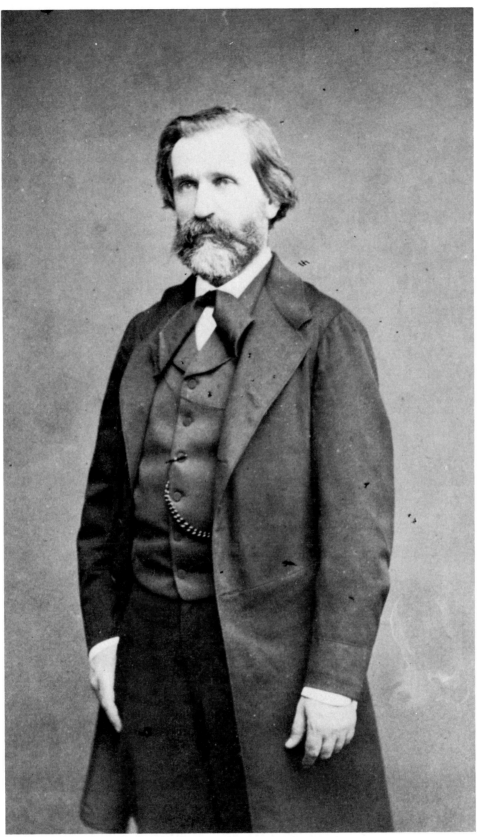

231

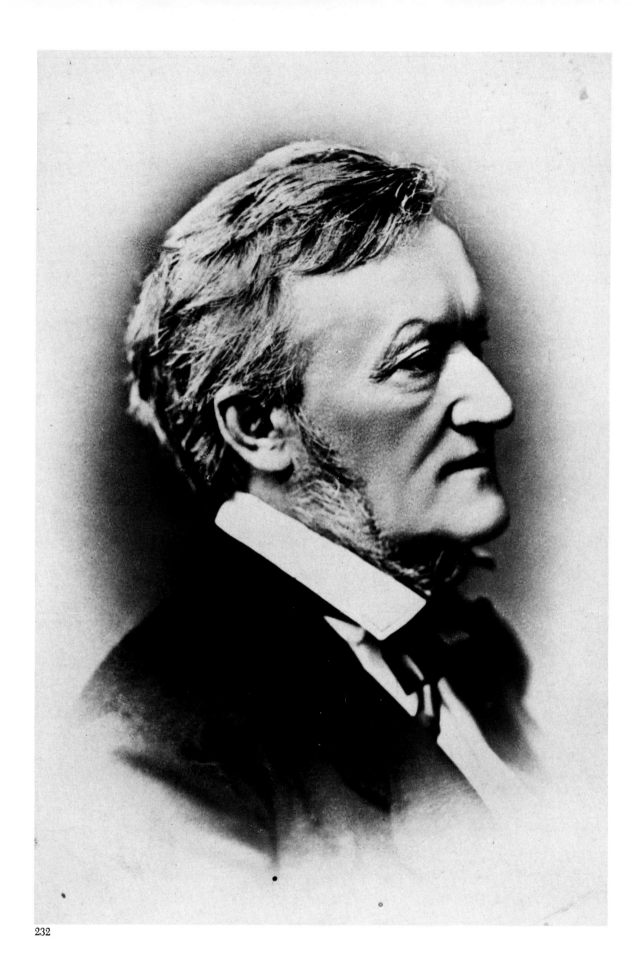

232

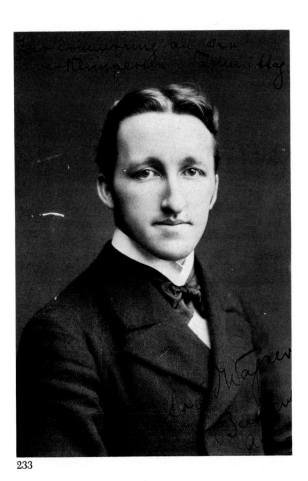

233

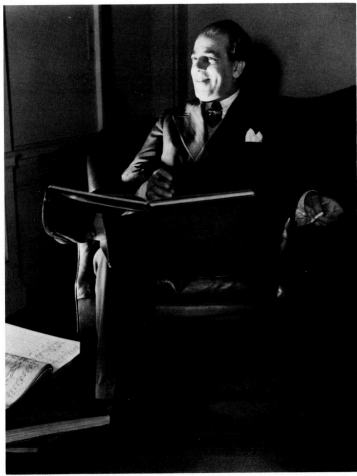

234

232. RICHARD WAGNER (1813–1883), German composer of operas. Wagner became one of the most celebrated composers in history through his "music dramas" *Tristan and Isolde* and *Das Ring des Nibelungen,* and the operas *Tannhäuser, Lohengrin* and *Die Meistersinger* — all to libretti written by himself. The Bayreuth theater was built, and the festival there founded, by Wagner himself to perpetuate his works as he conceived them. The works are still done there, but his conceptions have been dropped. 233. SIEGFRIED WAGNER (1869–1930), German composer, son of Richard Wagner and Cosima von Bülow (née Liszt), who later married Wagner. Siegfried composed several operas to his own libretti, but he is mainly remembered as general supervisor of the Bayreuth Festival from 1909 on. (Photo: London Stereoscopic Co., signed Bayreuth, 1895, "in remembrance of the afternoon tinkled away at the piano.") 234. HEITOR VILLA-LOBOS (1887–1959), Brazilian composer. Villa-Lobos's music is strongly rooted in Brazilian folk themes. His unique style has won him a wider audience than is usually granted to modern classical composers. He is most noted for his series of instrumental and vocal pieces called *Bachianas Brasileiras.*

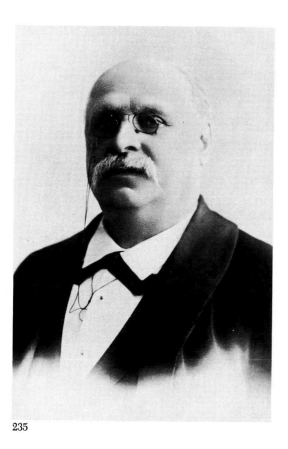

235

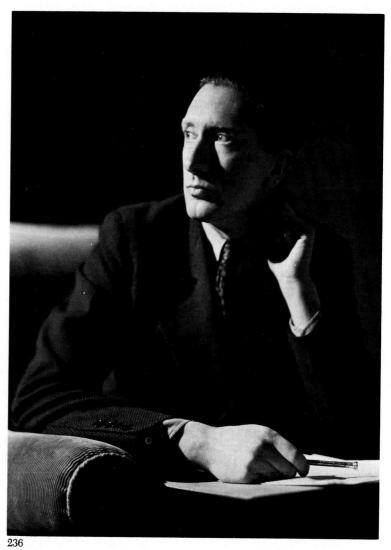

236

235. EMIL WALDTEUFEL (1837–1915), French (Alsatian) composer of waltzes, a few of which once rivaled Strauss's in popularity. His most famous were *The Skaters* and *Estudiantina*. 236. (SIR) WILLIAM WALTON (born 1902), British composer of many noted works including the oratorio *Belshazzar's Feast* and the opera *Troilus and Cressida*. 237. KURT WEILL (1900–1950), German composer, student of Busoni. In Germany Weill collaborated with Bertolt Brecht on such works as *The Threepenny Opera* and *The Rise and Fall of the City of Mahagonny*, and later entered a new career with such Broadway musicals as *Lady in the Dark* and *Lost in the Stars*. 238. FELIX WEINGARTNER (1863–1942), German composer and conductor. He wrote many operas and symphonic works, but was most celebrated as one of the foremost conductors of his time.

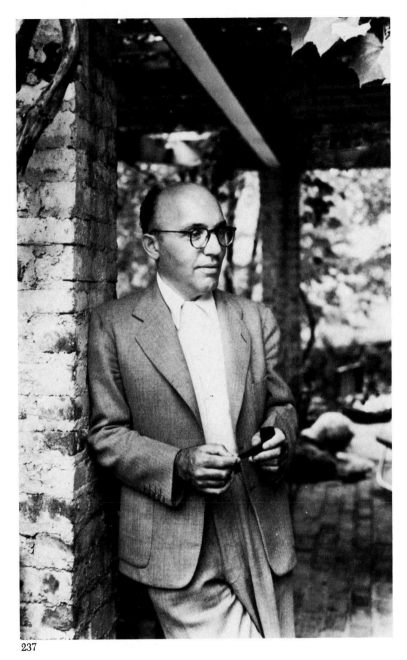

237

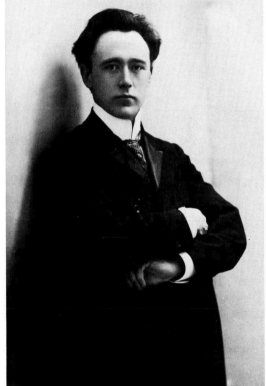

238

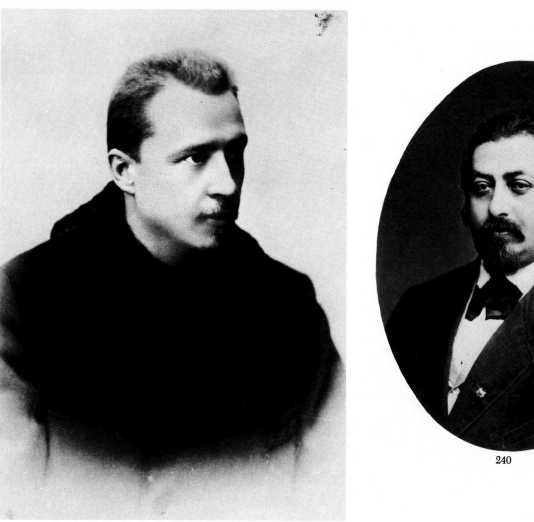

239

240

239. HUGO WOLF (1860–1903), Austrian composer. Wolf composed a noted opera, *Der Corregidor*, but he ranks as a master primarily for his many songs. 240. HENRYK WIENIAWSKY (1835–1880), Polish violin virtuoso and composer. He wrote successful violin concertos. 241. ERMANNO WOLF-FERRARI (1876–1948), Italian opera composer active in Germany. Wolf-Ferrari was the last successful composer of Italian opera buffa with such works as *La Donne Curiose, I Quattro Rusteghi, Il Segreto di Susanna* and *Il Campiello*. (Photo: Matzene, Chicago.) 242. HUGO WEISGALL (born 1912), American composer born in Czechoslovakia. Primarily a composer of operas based on major literary texts (by Racine, Pirandello, Strindberg, Yeats . . .) in a style evolved from the intense chromaticism of the second Viennese school. 243. ANTON VON WEBERN (1883–1945), Austrian composer, student of Schoenberg. Along with Berg and Schoenberg, Webern was a "prophet" of atonal music. He enlarged the 12-tone method and composed works that caused violent demonstrations when first performed.

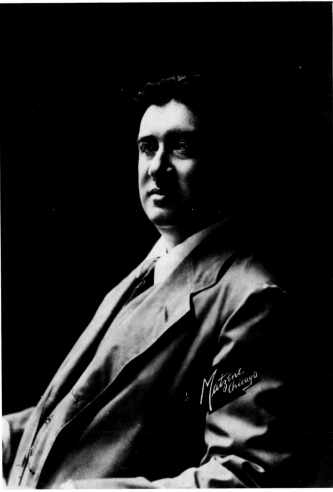

241

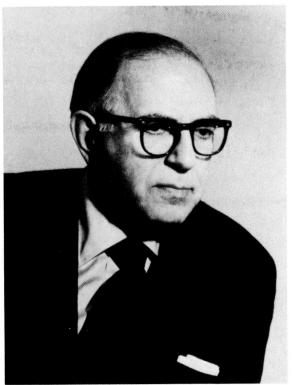

242

243

A CATALOGUE OF
SELECTED DOVER BOOKS

THE DEPRESSION YEARS AS PHOTOGRAPHED BY ARTHUR ROTH-STEIN, Arthur Rothstein. First collection devoted entirely to the work of outstanding 1930s photographer: famous dust storm photo, ragged children, unemployed, etc. 120 photographs. Captions. 119pp. 9¼ x 10¾.
23590-4 Pa. $5.00

CAMERA WORK: A PICTORIAL GUIDE, Alfred Stieglitz. All 559 illustrations and plates from the most important periodical in the history of art photography, Camera Work (1903-17). Presented four to a page, reduced in size but still clear, in strict chronological order, with complete captions. Three indexes. Glossary. Bibliography. 176pp. 8⅜ x 11¼.
23591-2 Pa. $6.95

ALVIN LANGDON COBURN, PHOTOGRAPHER, Alvin L. Coburn. Revealing autobiography by one of greatest photographers of 20th century gives insider's version of Photo-Secession, plus comments on his own work. 77 photographs by Coburn. Edited by Helmut and Alison Gernsheim. 160pp. 8⅛ x 11.
23685-4 Pa. $6.00

NEW YORK IN THE FORTIES, Andreas Feininger. 162 brilliant photographs by the well-known photographer, formerly with Life magazine, show commuters, shoppers, Times Square at night, Harlem nightclub, Lower East Side, etc. Introduction and full captions by John von Hartz. 181pp. 9¼ x 10¾.
23585-8 Pa. $6.00

GREAT NEWS PHOTOS AND THE STORIES BEHIND THEM, John Faber. Dramatic volume of 140 great news photos, 1855 through 1976, and revealing stories behind them, with both historical and technical information. Hindenburg disaster, shooting of Oswald, nomination of Jimmy Carter, etc. 160pp. 8¼ x 11.
23667-6 Pa. $5.00

THE ART OF THE CINEMATOGRAPHER, Leonard Maltin. Survey of American cinematography history and anecdotal interviews with 5 masters—Arthur Miller, Hal Mohr, Hal Rosson, Lucien Ballard, and Conrad Hall. Very large selection of behind-the-scenes production photos. 105 photographs. Filmographies. Index. Originally Behind the Camera. 144pp. 8¼ x 11.
23686-2 Pa. $5.00

DESIGNS FOR THE THREE-CORNERED HAT (LE TRICORNE), Pablo Picasso. 32 fabulously rare drawings—including 31 color illustrations of costumes and accessories—for 1919 production of famous ballet. Edited by Parmenia Migel, who has written new introduction. 48pp. 9⅜ x 12¼. (Available in U.S. only)
23709-5 Pa. $5.00

NOTES OF A FILM DIRECTOR, Sergei Eisenstein. Greatest Russian filmmaker explains montage, making of Alexander Nevsky, aesthetics; comments on self, associates, great rivals (Chaplin), similar material. 78 illustrations. 240pp. 5⅜ x 8½.
22392-2 Pa. $4.50

HOLLYWOOD GLAMOUR PORTRAITS, edited by John Kobal. 145 photos capture the stars from 1926-49, the high point in portrait photography. Gable, Harlow, Bogart, Bacall, Hedy Lamarr, Marlene Dietrich, Robert Montgomery, Marlon Brando, Veronica Lake; 94 stars in all. Full background on photographers, technical aspects, much more. Total of 160pp. 8⅜ x 11¼. 23352-9 Pa. $6.00

THE NEW YORK STAGE: FAMOUS PRODUCTIONS IN PHOTO-GRAPHS, edited by Stanley Appelbaum. 148 photographs from Museum of City of New York show 142 plays, 1883-1939. *Peter Pan, The Front Page, Dead End, Our Town,* O'Neill, hundreds of actors and actresses, etc. Full indexes. 154pp. 9½ x 10. 23241-7 Pa. $6.00

MASTERS OF THE DRAMA, John Gassner. Most comprehensive history of the drama, every tradition from Greeks to modern Europe and America, including Orient. Covers 800 dramatists, 2000 plays; biography, plot summaries, criticism, theatre history, etc. 77 illustrations. 890pp. 5⅜ x 8½.
 20100-7 Clothbd. $10.00

THE GREAT OPERA STARS IN HISTORIC PHOTOGRAPHS, edited by James Camner. 343 portraits from the 1850s to the 1940s: Tamburini, Mario, Caliapin, Jeritza, Melchior, Melba, Patti, Pinza, Schipa, Caruso, Farrar, Steber, Gobbi, and many more—270 performers in all. Index. 199pp. 8⅜ x 11¼. 23575-0 Pa. $6.50

J. S. BACH, Albert Schweitzer. Great full-length study of Bach, life, background to music, music, by foremost modern scholar. Ernest Newman translation. 650 musical examples. Total of 928pp. 5⅜ x 8½. (Available in U.S. only) 21631-4, 21632-2 Pa., Two-vol. set $10.00

COMPLETE PIANO SONATAS, Ludwig van Beethoven. All sonatas in the fine Schenker edition, with fingering, analytical material. One of best modern editions. Total of 615pp. 9 x 12. (Available in U.S. only)
 23134-8, 23135-6 Pa., Two-vol. set $15.00

KEYBOARD MUSIC, J. S. Bach. Bach-Gesellschaft edition. For harpsichord, piano, other keyboard instruments. English Suites, French Suites, Six Partitas, Goldberg Variations, Two-Part Inventions, Three-Part Sinfonias. 312pp. 8⅛ x 11. (Available in U.S. only) 22360-4 Pa. $6.95

FOUR SYMPHONIES IN FULL SCORE, Franz Schubert. Schubert's four most popular symphonies: No. 4 in C Minor ("Tragic"); No. 5 in B-flat Major; No. 8 in B Minor ("Unfinished"); No. 9 in C Major ("Great"). Breitkopf & Hartel edition. Study score. 261pp. 9⅜ x 12¼.
 23681-1 Pa. $6.50

THE AUTHENTIC GILBERT & SULLIVAN SONGBOOK, W. S. Gilbert, A. S. Sullivan. Largest selection available; 92 songs, uncut, original keys, in piano rendering approved by Sullivan. Favorites and lesser-known fine numbers. Edited with plot synopses by James Spero. 3 illustrations. 399pp. 9 x 12. 23482-7 Pa. $7.95

PRINCIPLES OF ORCHESTRATION, Nikolay Rimsky-Korsakov. Great classical orchestrator provides fundamentals of tonal resonance, progression of parts, voice and orchestra, tutti effects, much else in major document. 330pp. of musical excerpts. 489pp. 6½ x 9¼. 21266-1 Pa. $6.00

TRISTAN UND ISOLDE, Richard Wagner. Full orchestral score with complete instrumentation. Do not confuse with piano reduction. Commentary by Felix Mottl, great Wagnerian conductor and scholar. Study score. 655pp. 8⅛ x 11. 22915-7 Pa. $12.50

REQUIEM IN FULL SCORE, Giuseppe Verdi. Immensely popular with choral groups and music lovers. Republication of edition published by C. F. Peters, Leipzig, n. d. German frontmaker in English translation. Glossary. Text in Latin. Study score. 204pp. 9⅜ x 12¼.
23682-X Pa. $6.00

COMPLETE CHAMBER MUSIC FOR STRINGS, Felix Mendelssohn. All of Mendelssohn's chamber music: Octet, 2 Quintets, 6 Quartets, and Four Pieces for String Quartet. (Nothing with piano is included). Complete works edition (1874-7). Study score. 283 pp. 9⅜ x 12¼.
23679-X Pa. $6.95

POPULAR SONGS OF NINETEENTH-CENTURY AMERICA, edited by Richard Jackson. 64 most important songs: "Old Oaken Bucket," "Arkansas Traveler," "Yellow Rose of Texas," etc. Authentic original sheet music, full introduction and commentaries. 290pp. 9 x 12. 23270-0 Pa. $6.00

COLLECTED PIANO WORKS, Scott Joplin. Edited by Vera Brodsky Lawrence. Practically all of Joplin's piano works—rags, two-steps, marches, waltzes, etc., 51 works in all. Extensive introduction by Rudi Blesh. Total of 345pp. 9 x 12. 23106-2 Pa. $14.95

BASIC PRINCIPLES OF CLASSICAL BALLET, Agrippina Vaganova. Great Russian theoretician, teacher explains methods for teaching classical ballet; incorporates best from French, Italian, Russian schools. 118 illustrations. 175pp. 5⅜ x 8½. 22036-2 Pa. $2.50

CHINESE CHARACTERS, L. Wieger. Rich analysis of 2300 characters according to traditional systems into primitives. Historical-semantic analysis to phonetics (Classical Mandarin) and radicals. 820pp. 6⅛ x 9¼.
21321-8 Pa. $10.00

EGYPTIAN LANGUAGE: EASY LESSONS IN EGYPTIAN HIERO-GLYPHICS, E. A. Wallis Budge. Foremost Egyptologist offers Egyptian grammar, explanation of hieroglyphics, many reading texts, dictionary of symbols. 246pp. 5 x 7½. (Available in U.S. only)
21394-3 Clothbd. $7.50

AN ETYMOLOGICAL DICTIONARY OF MODERN ENGLISH, Ernest Weekley. Richest, fullest work, by foremost British lexicographer. Detailed word histories. Inexhaustible. Do not confuse this with Concise Etymological Dictionary, which is abridged. Total of 856pp. 6½ x 9¼.
21873-2, 21874-0 Pa., Two-vol. set $12.00

TONE POEMS, SERIES II: TILL EULENSPIEGELS LUSTIGE STREICHE, ALSO SPRACH ZARATHUSTRA, AND EIN HELDEN-LEBEN, Richard Strauss. Three important orchestral works, including very popular *Till Eulenspiegel's Marry Pranks,* reproduced in full score from original editions. Study score. 315pp. 9⅜ x 12¼. (Available in U.S. only)
23755-9 Pa. $7.50

TONE POEMS, SERIES I: DON JUAN, TOD UND VERKLARUNG AND DON QUIXOTE, Richard Strauss. Three of the most often performed and recorded works in entire orchestral repertoire, reproduced in full score from original editions. Study score. 286pp. 9⅜ x 12¼. (Available in U.S. only)
23754-0 Pa. $7.50

11 LATE STRING QUARTETS, Franz Joseph Haydn. The form which Haydn defined and "brought to perfection." (*Grove's*). 11 string quartets in complete score, his last and his best. The first in a projected series of the complete Haydn string quartets. Reliable modern Eulenberg edition, otherwise difficult to obtain. 320pp. 8⅜ x 11¼. (Available in U.S. only)
23753-2 Pa. $6.95

FOURTH, FIFTH AND SIXTH SYMPHONIES IN FULL SCORE, Peter Ilyitch Tchaikovsky. Complete orchestral scores of Symphony No. 4 in F Minor, Op. 36; Symphony No. 5 in E Minor, Op. 64; Symphony No. 6 in B Minor, "Pathetique," Op. 74. Bretikopf & Hartel eds. Study score. 480pp. 9⅜ x 12¼.
23861-X Pa. $10.95.

THE MARRIAGE OF FIGARO: COMPLETE SCORE, Wolfgang A. Mozart. Finest comic opera ever written. Full score, not to be confused with piano renderings. Peters edition. Study score. 448pp. 9⅜ x 12¼. (Available in U.S. only)
23751-6 Pa. $11.95

"IMAGE" ON THE ART AND EVOLUTION OF THE FILM, edited by Marshall Deutelbaum. Pioneering book brings together for first time 38 groundbreaking articles on early silent films from *Image* and 263 illustrations newly shot from rare prints in the collection of the International Museum of Photography. A landmark work. Index. 256pp. 8¼ x 11.
23777-X Pa. $8.95

Prices subject to change without notice.

Available at your book dealer or write for free catalogue to Dept. GI, Dover Publications, Inc., 180 Varick St., N.Y., N.Y. 10014. Dover publishes more than 175 books each year on science, elementary and advanced mathematics, biology, music, art, literary history, social sciences and other areas.